Humble Moms

Other Books by Kristen Wetherell

Hope When It Hurts

Fight Your Fears

12 Faithful Women

Humble Moms

How the Work of Christ
Sustains the Work of Motherhood

Kristen Wetherell

PUBLISHING
NASHVILLE, TENNESSEE

978-1-0877-5101-6

Published by B&H Publishing Group
Nashville, Tennessee

Dewey Decimal Classification: 306.874
Subject Heading: MOTHERHOOD /
HUMILITY / CHRISTIAN LIFE

Cover design by Emily Lambright. Imagery © Julia Dreams/ creative market. Author photo by Lianna Davis.

1 2 3 4 5 6 • 26 25 24 23 22

To Joanna and John,
two gracious gifts from God:

It is my privilege to love and serve you
as Jesus has first loved and served me.
May you believe that Jesus is the Christ,
the Son of God, and have eternal life in his name.

Contents

Introduction: What's in a Mom? . 1

Part 1: Humility in the Flesh

Chapter 1: He Made You . 13

Chapter 2: He Came to You . 25

Part 2: A Humble Servant

Chapter 3: He Changes You . 39

Chapter 4: He Satisfies You . 51

Chapter 5: He Provides for You 63

Chapter 6: He Leads You . 75

Part 3: Humble unto Death

Chapter 7: He Loves You . 89

Chapter 8: He Takes Your Place 101

Chapter 9: He Reveals Himself to You 113

Part 4: Humble in Heaven

Chapter 10: He Prays for You . 127

Chapter 11: He Dwells in You . 139

Chapter 12: You Will See His Glory 151

Acknowledgments . 163

Discussion Questions . 165

What's in a Mom?

[Humility] is being clothed with the very

beauty and blessedness of Jesus.[1]

A N D R E W M U R R A Y

[1] Andrew Murray, *Humility: The Journey Toward Holiness* (Bloomington, MN: Bethany House, 2001), 11.

This book is for you, mom in the trenches with young (or older) children.

It's for you, tired mom, who finds it impossible to nap when your kids do because you hear their cries even when they are fast asleep.

It's for you, jaded mom, who wonders when your children became a burden rather than a blessing.

It's for you, disappointed mom, whose hopes and dreams about having kids came true, yet you find yourself unsatisfied even on the best days.

It's for you, anxious mom, who is willing to sacrifice almost anything to know your kids will be okay, yet you go to sleep at night feeling inadequate or fretful with that nagging feeling that what you offered today simply wasn't enough, and you know the next day will only bring more needs and fresh strivings.

It's for you, disheartened mom, who reads your Bible in one moment, hopeful for change, and in the next, finds yourself yelling at your kids and melting down on your closet floor, feeling like a failure.

It's for you, disconnected mom, who does all the right things, yet feels sort of flat within your soul. The outer person is furious with activity—keeping up the schedule, getting everyone where they need to go on time, bathing and feeding and putting to bed—but the inner person feels dormant.

It's for all of us moms who have a suspicion in the back of our minds that won't leave us alone: *I'm just not measuring up.*

This book is for you and for me. We are moms who love our children and know the privilege of our high calling, but see its demands, along with our struggles and shortcomings, and know, without a doubt, how much we need encouragement and help along the way.

· · · — · · ·

Motherhood is a gift, we know, but it is also one of the most challenging jobs we have ever worked. Yes, our kids are God-given joys. They make us smile, bring us to tears with laughter at their

antics, and remind us how to be young again. Yet, in the next breath, we're thinking about sending them back, and our tears are the result of overwhelm and discouragement, from sinning and being sinned against, or perhaps because life itself has thrown us a curveball.

As a mom of two young children, this has been true for me. Upon the writing of this book, our daughter is three-and-a-half and our son is one. We are very much in the little years. Added to this, our family has gone through several major changes in the last year. My husband's new pastoral position meant a new job, a new church campus, and a new home in a matter of three months. (Oh, and did I mention we had a new baby?)

Between my two kids and all these shifts, I have come to the end of my strength and wondered how to take another step. I've worked plenty of jobs in my lifetime, but no job has occupied so much of my mind, time, devotion, and energy as motherhood.

I wonder if you agree.

Maybe you're a stay-at-home mom, or perhaps you work another job. Maybe you are married, or perhaps you're raising your kids without a spouse. It could be that you are expecting your first child (congratulations!) and you are over the moon. Or perhaps you're expecting a "surprise" fourth baby and, while you're grateful for the news, you're wondering how in the world you'll be able to handle another child when three feels like too many. Maybe you're fostering or adopting kids, which has not been what you hoped it would be, and the parent-friends you have don't understand what it takes to be a mother in the way you're a mother.

Whatever your context, you know that your work as "mom" never ceases. Whether you are at home or away, your children need you, and you are never off the clock.

Next to motherhood, I imagine some of you may be dealing with other factors: job loss and financial strain, relational tension with a spouse or child, evolving friendships and loneliness, physical weakness from pregnancy, illness, or miscarriage, an empty nest that makes you wonder what motherhood even means in this strange

new season with adult children, even the blessed trial of caring for aging parents or the grief of saying goodbye to them.

Maybe you would describe your world at home as full and frantic as you manage a large family, needing all hands on deck. Or maybe your world feels tiny and isolated, like every day c r a w l s by, and you wonder what happened to your sense of purpose. Either way, amid the chaos or quiet, you wonder if this is all there is to being a mom.

Add your circumstances to the everyday, relentless nature of motherhood, and our collective weariness is understandable. But as I look at my own story, and as I talk to friends about theirs, it seems to me there's something deeper going on, something rooted less in our circumstances and more within the core of our being:

Our weariness often seems to come from a disconnection between hands and heart.

We are busy serving, meeting our children's needs while setting aside our own, and pouring ourselves out for these little ones. We're using our hands to change diapers, nurse babies, read books, build towers, teach lessons, make lunches, and tend boo-boos. But if we're honest we would admit that, while we love our kids, we don't always like our situation. We struggle to enjoy it. It feels exhausting.

All day long, we work with a servant's hands—but not always with a servant's heart.

Many of us desperately want our motives to align with our actions. We *want* our hands to follow our hearts. We don't just want to keep our kids alive, but to raise them with gladness and thankfulness. Instead of a dormant or a resentful heart, we genuinely want a humble one.

A heart like Christ.

But how?

How do we go about the weighty and wonderful calling of motherhood not simply as servants, but with servants' hearts—*humble hearts?*

When
we
behold
our
Savior,
we find
that his
heart
starts to
change
our own.

For he alone has the power
to transform and sustain us every
moment and in every type of work—
including the work of motherhood.

• • • ━━ • • •

As I was pondering this question one day, my thoughts turned to Philippians 2, a well-known Bible passage on humility. Throughout the verses below (which I've broken up so that you can read through it slowly and really take it in), notice how Christ's humble heart is displayed within each facet of his salvation work:

> So if there is any encouragement in Christ, any comfort from love, any participation in the Spirit, any affection and sympathy, complete my joy by being of the same mind, having the same love, being in full accord and of one mind.
>
> Do nothing from selfish ambition or conceit, but in humility count others more significant than yourselves.
>
> Let each of you look not only to his own interests, but also to the interests of others. *Have this mind among yourselves, which is yours in Christ Jesus,* who, though he was in the form of God, did not count equality with God a thing to be grasped, but emptied himself, by *taking the form of a servant, being born in the likeness of men. And being found in human form, he humbled himself by becoming obedient to the point of death, even death on a cross.*
>
> *Therefore God has highly exalted him* and bestowed on him the name that is above every name, so that at the name of Jesus every knee should bow, in heaven and on earth and under the earth, and every tongue confess that Jesus Christ is Lord, to the glory of God the Father. (Phil. 2:1–11, italics added)

The question, "How does a mother grow in humility on the heart-level and not just the hands-level?" seems to have an obvious answer throughout this passage ("Jesus!"). But as we look more closely, we see there are riches to mine in it. True, we grow in humility as we walk closely with Christ, but why is this so? *What makes Jesus uniquely able to impart humility to his people?*

This is the question we will explore in this book.

My goal, then, is not to give you more things you must do or be, adding to your already-long-enough list of *shoulds*, nor will we grow in humility simply by focusing on our shortcomings and sins as we walk with Christ. The pages that follow are not about parenting; neither is this book a pep talk to bolster your self-confidence. It is not even directly about motherhood, although I'm praying your pursuit of motherhood is affected by it.

Instead, this book is about a person whose heart we most need. It is about the truest definition and demonstration of humility. This book is a meditation on Christ—because what weary moms need is a long, lingering look at humility in the flesh, the beautiful and blessed Jesus, who reveals to us what servant-heartedness looks like:

Jesus is the one who took the form of a servant (Phil. 2:7).

Jesus is the one who came not to be served, but to serve (Matt. 20:28; Mark 10:45).

He is the one whose very heart is gentle and lowly (Matt. 10:28) and whose nail-scarred hands serve his people as he serves his Father (John 4:34).

This is a book about Jesus, and how beautifully he has served us in both hand and heart.

· · · —— · · ·

As you know well in this season, time for reading can be hard to come by and may feel like a fanciful wish. So I have made the chapters in this book concise. Each one offers a brief meditation on the humility of Jesus as recorded by the apostle John in his Gospel.

There is a short application section called "Bring It Home," and an "Extra Reading" suggestion if you want to dig deeper into the text (either by yourself or with a group of moms). There's also a Discussion Guide at the end for use in small group or book club settings.

As we make our way through John's Gospel, we will see how Jesus's humility shines forth, how he has given himself to God the Father's work, and how he lives to serve his people, including you and me. His humility is displayed in his manifold gospel-work, which is all about *good news*—and I don't know about you, but I'm a weary mom who needs good news!

As we journey through the book of John together, we will look at Jesus's humility:

1. In creation *(his preexistence)*
2. In his coming to earth as a human *(his incarnation)*
3. In his words, works, and miracles during his earthly years *(his life and ministry)*
4. Through his willing, substitutionary sacrifice for sinners and subsequent defeat of death *(his death and resurrection)*
5. At his throne right now in heaven *(his ascension and intercession)*
6. In his promise to come back for his people *(his return)*

When we hear the word *gospel*, many of us think only about Jesus's work on the cross. But the gospel is multifaceted, so we are going to look at Jesus's *humility* in each aspect of it. His humble heart is there, at every turn. And when we behold him, we find that the heart of the Savior starts to change our own. For he alone has the power to transform and sustain us *every* moment and in *every* type of work—including the work of motherhood.

• • • — • • •

You may be in your house, knee-deep in your schedule, caring for your kids, and managing the craziness, and I may be in mine. But together, in Christ, you and I are a *we* in this thing called motherhood.

We are moms who need encouragement and help, and the good news is this: *Jesus lives to serve us.*

Even in the shadows and the trenches and the exhaustion of it all. Especially there, in fact.

As you read this book in the midst of what feels like relentless demands in an intense season, my prayer is that you will *rest*, that you will behold and enjoy the beautiful Son of God, who has served you and who continues to serve you as you serve your children. My hope is to give you glimpses of Jesus that will train the eyes of your heart to look to him in the marathon of motherhood, as you seek to serve with your hands—and also with your whole heart.

PART 1

Humility in the Flesh

He
Made
You

In the beginning was the Word, and the Word was with God, and the Word was God. He was in the beginning with God. All things were made through him, and without him was not any thing made that was made. In him was life, and the life was the light of men. The light shines in the darkness, and the darkness has not overcome it.

JOHN 1:1–5

EXTRA READING: John 1:1–18

Who gets the credit for bearing a child?

The baby, or the mother?

Take a moment to remember the birth of your first baby. If your experience was anything like mine, you labored for hours on end with trembling, sweat, and groans, enduring excruciating pain for the joy set before you: a precious newborn. Now imagine that after all is said and done, you hold your baby in your arms, and your daughter or son looks up at you and says, "I did a pretty good job, didn't I?"

The picture of a talking baby is ridiculous, of course, but so is the thought that any child, born of his or her mother, could take the credit for being alive. No baby gives birth to him or herself; the mother did all the hard work. She carried the child, labored over the child, and, with some helping hands, delivered the child. Even after this, the baby's mother will sustain his or her life.

No human being can take credit for existence. We are weak, helpless, and entirely dependent on our parents from the moment of conception—

From the beginning.

· · · — · · ·

In the opening verses of John, we read about another beginning, the birth of creation itself, and we read of the One who existed even before the beginning began:

> In the beginning was the Word, and the Word was
> with God, and the Word was God. He was in the
> beginning with God. All things were made through
> him, and without him was not any thing made that
> was made. In him was life . . . (John 1:1–4)

John, the author, holds nothing back from the start. He dives into the depths of who God is and invites us to swim with him there. So, friends, let's dive with him. His theology may be deep but it is also deeply practical and will actually *help* us. The rest of his Gospel

(and this book) are dependent on what he says—and what he says is profound: "In the beginning was *the Word* . . ."

Who is this Word? John goes on: He is "with God," and he is also God. To be "with" someone implies a distinction between two people, so John is telling us how God and the Word are the same and also distinct. A few verses later, we learn how the Word would become flesh (1:14)—a truth we will explore in the next chapter— and so we can rightly conclude that this Word became Jesus, the holy Son of the Father who clothed himself in humanity and came to us.

But before the Son of God came, *he was.*

Just as historical events come into focus when we learn what happened beforehand, John wants us to zoom out and get the big picture about the divine nature of Jesus before we zoom in on his earthly ministry. But this big picture is unique since the Author of history, in all his divine glory and power, has always existed outside of space and time—something theologians call "infinitude." And infinitude is impossible to comprehend for finite creatures like you and me. (But not impossible to desire—what mother wouldn't love to be infinite?!)

When you hear the phrase "in the beginning," does it feel like you've heard it before? John intentionally uses this phrase to jog our memory about Genesis 1: "In the beginning, God created the heavens and the earth. . . . And the Spirit of God was hovering over the face of the waters" (Gen. 1:1–2). John wants us to see how the Word, the Son of God, is the life-giving Creator at the beginning, the one and only God who made and sustains everything.

The Son—the second person of the Trinity—is God and always has been. Dwelling in perfect unity with the Father and Spirit before the beginning of time, the Son of God is the Word, speaking into being the things that once did not exist and making all things, including time and history themselves. "Without him was not any thing made that was made" (John 1:3).

This is good news, Mom: *nothing—nothing at all—exists apart from Jesus.* All things hang upon, rely upon, depend upon the Word of life. Including you and me. Including our kids. Including the little

basil planters in our kitchen window (that we may or may not remember to water).

We're all under the jurisdiction of everything the Son of God created, owns, and sustains.

At the end of the day, friend, it's not you that keeps the world spinning. It is Christ. (Whew!) Colossians 1:17 would put it this way: "He is before all things, and in him all things hold together." That's his work: holding all things together. So, let his work sustain yours today. After all, he made and upholds everything you are accountable for, long before you ever laid eyes on any of them.

. . . — . . .

For a brief moment, let's consider the Trinity. Are you ready?

How might we describe the relationship between Father, Son, and Spirit?

Here's what Jesus said about it when he walked the earth:

> "Truly, truly, I say to you, the Son can do nothing of his own accord, but only what he sees the Father doing. For whatever the Father does, that the Son does likewise. For the Father loves the Son and shows him all that he himself is doing." (John 5:19–20)

> "[The Spirit of truth] will glorify me, for he will take what is mine and declare it to you. All that the Father has is mine; therefore I said that he will take what is mine and declare it to you." (John 16:14–15)

> "And now, Father, glorify me in your own presence with the glory that I had with you before the world existed. . . . you loved me before the foundation of the world." (John 17:5, 24)

At the end
of the day,
friend,
it's not you
that keeps
the world
spinning.

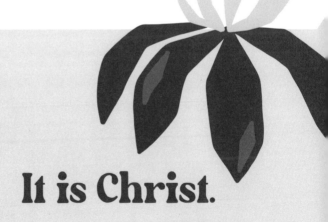

It is Christ.

How beautiful. The Trinity is a picture of perfect, everlasting relational happiness. God is love (1 John 4:8), and so Father, Son, and Spirit love one another with perfection. Think about the happiest relationship you have, perhaps with your spouse, kids, a family member, or a friend. A healthy, loving relationship brings mutual enjoyment. Now imagine an intimacy with zero limits and infinite happiness with a companion who never disappoints!

This is what God enjoys in himself between Father, Son, and Spirit: unconditional love, unrestricted delight, and fullness of joy. Sweet fellowship, perfect companionship.

In light of this, an important question begs to be answered:

Why would a perfectly holy and happy God choose to create anything?

If his happiness and enjoyment are complete *in himself*, why on earth would he choose to create *us*? This is a wonder. And here's the answer, plain and simple:

Because this pleased him.

What does this mean for you, Mom? It means that creation isn't a result of divine obligation, as though God had to create us because he is God. Rather, creation is the overflow of divine good pleasure; God *wanted* to create us because he is love. This is the uncreated, eternally existent Trinity's very nature (1 John 4:8), and he chooses to express this love through the act of creation. It's as if the heart of God can't be contained—it bursts at the seams with pure affection.[1]

If you are married, consider the love that you and your husband share, however imperfect it may be. Your affection has overflowed and produced a child or multiple children, or maybe you have chosen to adopt; and even if you haven't had kids yet or are trying now, you have pursued this end because you know it will increase the joy in your home and point back to your committed, faithful love.

[1] One of the best books I've read on God as Trinity is Michael Reeves's *Delighting in the Trinity*. It is very accessible and will stir your heart to worship!

As children reflect their parents' good pleasure, creation reflects its God.[2]

The Son of God made you, and he did so because it delighted him. Take that in again: the very making of you *delighted* him.

You were created *from joy* and *for joy*: the joy of loving dependence on your Creator.

So, friend, this doesn't just mean that you are under the jurisdiction of everything the Son of God created, owns, and sustains. It means you *are included* in what the Son of God *delighted* to create, *loves* to own, and sustains *with good pleasure*.

He didn't just make you. He doesn't just sustain you (and all the things you manage).

He wanted to. He likes to. He enjoys it.

You aren't a burden. You, and everyone that comes with you, are part of his good pleasure.

· · · —— · · ·

David, one of Israel's kings and a writer of many psalms, once marveled at the shocking beauty of this truth:

> O LORD, our LORD,
> how majestic is your name in all the earth!
> You have set your glory above the heavens. . . .
> When I look at your heavens, the work of your
> fingers,
> the moon and the stars, which you have set in
> place,
> *what is man that you are mindful of him,*
> *and the son of man that you care for him?*
> (Ps. 8:1, 3–4, italics added)

[2] Every aspect of creation does this (Rom. 1:20), but especially human beings (Gen. 1:26). He made us in his image, after his likeness.

David makes a striking contrast here. The Son, the Word at the beginning who ruled above the earth and the heavens (and still does), who was entirely unapproachable because of his perfect majesty, stooped to notice us and care for us. The act of caring for his creation brings God joy just as the act of creation itself does.

He created us in order to care for us. *To serve us.*

One of my favorites places to go is Arizona. My sister and her husband live there, so we visit every year to enjoy time with them. Coming from the lingering Midwest winter and flatlands, we yearn for the sunshine to thaw our faces and for a sight of the desert red. Truly, there is no stargazing like that below an Arizonan night sky. Before the majestic mountains, surrounded by the clear evening air and the starry blackness above, I'm made more aware of my smallness, my temporariness.

The presence of so mighty and lasting a creation invites proper perspective. How much more the presence of the almighty and everlasting Creator who has breathed life into everything from the fullness of his love?

Who are we that the Lord Jesus is mindful of us? His attention and care is astonishing.

In the middle of a typical Monday, when our tanks are empty by noon and the day hasn't gone as we'd hoped it would, this makes a difference. Our natural tendency is to wonder if God cares. *Is he near?* Sure, he made us, we know, but we somehow suspect that he's distant, aloof. That perhaps he did his part in creating us, but now it's up to us to figure out how to get through our days in one piece.

That Jesus, the eternal Word, made us from joy and for joy silences our suspicions. He created us from his fullness, and he cares for us from that same fullness. He served us into existence, and he continues to serve us as he cares for us.

In the middle of your Monday, your Maker is mindful of you.

· · · — · · ·

Who gets the credit for the fact that you're breathing right now? Who has, in essence, served you into existence?

"In him was life" (John 1:4).

John helps us remember that the Son of God, the Word, our Creator, has breathed life into us and given us the gift of joyful dependence on him, not because we are wonderful in ourselves, but because he is. He is more majestic than the most jaw-dropping mountains, and more glorious than any pristine starry night. He is the definition of full, complete, satisfied, infinite love. And because this Creator is ours, and we belong to him as his creation, he is ultimately the only One worthy of our worship and dependence, and the only One in whom our purpose as moms can be found.

As human beings (and mothers!) made in the image of God, it is important for us to affirm the dual realities David describes in Psalm 8.

First, we possess created worth because of who our Creator is—not from anything we have done or been or achieved or earned by ourselves. This is an especially important truth for moms to dwell on since our culture tells us that worth must be proven, that self-actualization is our goal, and that an idealistic home and children are what make us valuable. Scripture affirms the opposite: we have intrinsic worth because the Son, the Word of God himself, made us. More than that, he delighted in making us.

Second, while we possess created worth, we are not worthy of our Creator. What is most remarkable about God's mindfulness of us isn't merely that we are creatures, but that we are fallen creatures.

Jesus—the Word of life, the Creator of all things, God the Son from before the beginning—made us to depend on him, reflect him, and enjoy him forever; but instead of basking in his worthiness and worshiping him alone in humble dependence, we have chosen otherwise.

Astonishingly, his care for us extends beyond the earth he made even to the depths and darkness of our sin.

Sin that he came to do something about.

BRING IT HOME

Meditate

Jesus, your Creator, delighted to serve you into existence, and he continues to serve you as he cares for you out of his good pleasure, endless power, and perfect humility.

Reflect

Knowing that Jesus is the Son of God—the life-giving, life-sustaining Creator of all things—what would it look like to entrust all of today's details to him?

PRAY

Word at the beginning.

You are worthy of my worship. You created all things, including my kids and me. We don't belong to ourselves, nor do we sustain ourselves, and that is a freeing reality. Help me receive today as a gift from you. When I am tempted to think that you're distant from me or that you don't care, help me remember that you made me from the fullness of your perfect love that you *delighted* in making meand help me bring honor and praise to your name as I depend on you. Amen.

CHAPTER 2

He Came to You

And the Word became flesh and

dwelt among us, and we have seen his

glory, glory as of the only Son from

the Father, full of grace and truth.

JOHN 1:14

EXTRA READING: John 1:1–18

How has Jesus served us?

That's the question this book seeks to answer. As moms, we love our children and wouldn't trade motherhood for anything; yet, as we've talked about before, there's often a disconnect between what our hands are busy doing and what our hearts feel.

What we see in Jesus, though, is a humble heart that fuels everything he does, a servant's heart, and it is one we long to have ourselves. So far we have seen how Jesus's humility has perfectly spurred on the work of his hands in creation, how he has served us into existence from the infinite fullness that flows from perfect Trinitarian love.

He made us, and he cares for us.

Now that John, the Gospel writer, has set the scene on the big-picture level, he zeroes in on the subject of the rest of his book: "And the Word became flesh and dwelt among us."

Remarkable. This statement is meant to startle us.

Before we swim in the depths of this beautiful truth, though, consider the following question: *When is it hardest to serve your kids?* Typically, it's not when they are behaving well—it's easy to love them then—and usually not when the day is going according to plan. On the contrary, it's hardest to serve our children when no one, or nothing, seems to be serving us in return, when our rights or authority (or even our very presence in the room!) seem disregarded, or when we are not getting what we want or think we deserve.

But consider: If anyone has a good reason for thinking it's hard to serve, it is Jesus.

Yet this is precisely what he came to do in his incarnation.

The Word becoming flesh defies our expectations in two major ways.

· · · — · · ·

First, the light of the world willingly chose to enter the world's darkness: "The true light, which gives light to everyone, was coming

into the world. He was in the world, and the world was made through him, yet the world did not know him" (John 1:9–10). I don't know about you, but I'm not one to naturally lean into what is hard and painful; I usually want to avoid conflict, toil, tension, and brokenness.

But Jesus didn't avoid it. He willingly came into our darkness.

For us to begin grasping how lowly Jesus is, we must first grasp the depths of our sin. As John harkens back to the creation of the world in Genesis—when the Word of God declared, "Let there be light"—he also wants us to recall how light was accompanied by darkness: "The light shines in the darkness, and the darkness has not overcome it" (John 1:5).

When the first man and woman sought their own way and rejected God's way, they cast themselves, and each of us, into spiritual darkness and death with all its ripple effects. Now childbearing is painful, work is difficult, relationships are full of tension, and suffering accompanies all of it (Gen. 3).

Motherhood is no exception. In this way, you are not crazy, friend, for thinking it is hard—it is. It's full of thorns and darkness just like every other human endeavor under the Fall.

The source of the darkness? *Our hearts.* "For although they knew God, they did not honor him as God or give thanks to him, but they became futile in their thinking, and *their foolish hearts were darkened.* . . . they exchanged the truth about God for a lie and worshiped and served the creature rather than the Creator, who is blessed forever! Amen" (Rom. 1:21, 25, italics added).

Jesus would put it this way: "But what comes out of the mouth proceeds from the heart, and this defiles a person. For *out of the heart come* evil thoughts, murder, adultery, sexual immorality, theft, false witness, slander. These are what defile a person" (Matt. 15:18–20, italics added).[1] What comes out of us are merely shadows

[1] Lest we focus on the more terrible things Jesus lists—murder, theft, adultery, sexual sin—in hopes of clearing ourselves of guilt, we need to remember his words in Matthew 5:21–22: "You have heard that it was said to those of old, 'You shall not murder; and whoever murders will be liable to judgment.' But I say to you that everyone who is angry with his brother will

of a deeper problem: the darkness of sin. In other words, we tend to think the worst darkness in the world is happening *outside* of us, but the worst darkness in the world is also happening *inside* of us.[2]

Our kids are walking demonstrations of the internal human conflict between light and darkness. From their earliest days, children instinctively know what is right and wrong, even if they can't articulate it—and often *wrong* wins. The desire to want what they want, and to get what they want, strongly controls them (as it does adults). Even after we have called Christ Savior and Lord and dedicated our heart, soul, mind, and strength to him, the battle against the remaining darkness within us—our fight against sin—continues.

Sin's darkness is the pervasive shadow over our world.

Yet the light of the world entered our darkness. Jesus could have asserted his holy right to stay far, far away from sinners—he is God!—but instead he would inhabit the same world he made, the world that had rejected his rule and scorned his love.

The eternal Word would willingly choose to enter time and space.

· · · — · · ·

There in the ultrasound room with my husband, I will never forget laying eyes on our daughter for the first time.

As the technician touched her device to my womb, an entire world opened before us on camera. There, in a dark, hidden place was life.

Watching our daughter wiggle around, completely at ease, and seeing her tiny heart pulse was nothing short of humbling. Life begins in such a small and unsuspecting way, as two microscopic cells collide to create a unique human being.

be liable to judgment." Sin goes beyond the *hands* to the *heart*. We also need to consider the rest of the list—evil thoughts (guilty), false witness (guilty!), slander (guilty again)—which I'd imagine many mothers struggle with on a more regular basis.

[2] This isn't to say that all sin holds the same degree of evil, but that all sin is sin and still a terrible darkness that resides in the human heart.

Yet, even more astounding than this is how *the Son of God willingly chose to become like us, a human wrapped in flesh—a baby.*

The One who created his mother Mary became a baby in her womb.

The One whose infinite being could not be measured became measurable.

Imagine if there had been ultrasounds in Mary's day. Imagine if she too had looked upon the secret place of her womb and seen a little life floating around and a tiny beating heart, knowing that this baby was also God. When the angel Gabriel told Mary about Jesus being conceived in her by the power of the Holy Spirit, she said in response, "Behold, I am the servant of the Lord; let it be to me according to your word" (Luke 1:38).

Mary says she is God's servant, yet God had come to serve her.

Jesus's earthly life began as all of ours did. He cried. He needed his mother for sustenance, waking her in the night to eat. He needed to be dressed and his dirty diapers changed. He needed to be taught the basics, how to sit up on his own and grab things and walk and talk. Babies are the most helpless creatures on earth, yet the infinite Creator, who has zero limits or needs, willingly—joyfully—became one of them.

· · · —— · · ·

Beneath these two astounding truths—that Jesus willingly came into our dark world and became a human being—is the reality of what Jesus left behind him.

He left his deserved high position in heaven and made his home in the dust of earth.

He left his perfect, loving relationship with Father and Spirit to walk among men who would imperfectly love and follow him at best, and reject and crucify him at worst.

He left his unseen form as God of the universe and confined himself to a human body.

"He did not insist on coming into the world in a blaze of glory, but came instead in humility," says Sinclair Ferguson.[3] In coming to us, Jesus did not grasp at all the things he rightfully possessed, all he truly deserved as God.

Yes—if anyone has had a good reason for thinking it's hard to serve, it is Jesus.

Yet the only person who truly deserves to be served came instead to serve us.

· · · —— · · ·

I have lost count of the number of times I've had to stop writing this chapter.

In the quiet of the morning our daughter comes down the stairs; writing time is over for now, and the day begins. My son wakes up from his nap—*pause*. My daughter's play time or screen time is over. *Until tomorrow . . .*

And I will be honest with you: My response has not been to set this book aside with a happy heart and serve my children, considering it my joy to do so with them as my priority. No—my reaction has been *annoyance* at the so-called interruptions, and a sense of loss at what I must leave behind me each time I am needed.

The irony is not lost on me, friends.

I wonder how you similarly struggle with a relinquishment of worldly "glories." A well-rested night gives way to multiple wakings and subsequent fatigue; your child's situation distracts you at work when your mind is supposed to be focused there; you can't make that fun social event—the one you really wanted to attend—because of your sick little one; the other ministry opportunity allures more than the unfolded socks awaiting you in the dryer.

What does "glory" look like to you, Mom? What rights—good things, not bad—do you naturally want to grasp at, frustrated that

<hr>

[3] Sinclair Ferguson, *Child in the Manger* (Edinburgh, UK: Banner of Truth, 2015), 50.

you cannot enjoy sometimes? For mothers, the answer to that usually isn't flashy. A quiet car ride. A nap. A cup of coffee that you actually get through before the needs of the day start rolling in.

None of those desires are selfish in and of themselves, and yes, sometimes we need to rest. We can't pour out as "mom" if we are not being poured into. Our bodies sometimes warn us that we need to be refueled, and we should pay attention to that (indeed, Jesus pulled away sometimes).

And so the problem doesn't lie in the good things we'd like to enjoy or the rest we need; it is when we grasp at those gifts like they are more important than other human beings. The problem is the inner resistance we feel when it comes to serving others because, deep down, we'd rather be served. The issue lies in our lack of humility—the fact that serving others always seems to feel like a fight in our hearts, however well-hidden.

I'm too good to stoop in this way. This is beneath me.

But that darkness we fight in our hearts is precisely what the Light of the world came to remedy. Serving sinners, and ultimately serving his Father, has always been Jesus's ambition and his joy. He "did not count equality with God a thing to be grasped, but emptied himself, by taking the form of a servant, being born in the likeness of men" (Phil. 2:6–7).

Each day presents us with opportunities to lower ourselves as Christ lowered himself.

And this is our privilege because it was his.

Lest we think our moments of selfishness drive him further away from us, causing him to wag his head at our continuing failures, we need to remember a vital truth:

It is our sin and desperate need for rescue that compelled God's Son, from the infinite stores of his love and faithfulness, to come in the first place.

And for all those who are his, it is our remaining darkness and daily need for strength that compel him to help us even now.

What is the "glory" that John says "we have seen"?

The goodness of God put on display in his Son.

This is the whole point of John's Gospel. We are about to behold the literal fleshing out of how Jesus has dwelt among us and showed us undeserved grace—how he has served all of his people. Including moms. Including you.

$$\cdots \ \textbf{---} \ \cdots$$

Here is Jesus's promise for every mother who will depend on him: "I am the light of the world. Whoever follows me will not walk in darkness, but will have the light of life" (John 8:12). As we choose to follow Jesus in faithfulness, we will find the darkness of pride and selfishness in our hearts increasingly diminished.

As we wipe soiled bottoms for the millionth time—

As we play the same imaginary game on repeat—

As we try to understand the sadness behind our child's tears—

As we empty our supposed "rights" as mothers, laying aside our glory—

We are not only serving our kids, we are serving the One who has first given up everything he deserved to serve us.

The truth is, not one of us has condescended to the level that Jesus has. It may feel that way sometimes when we are beside-ourselves-exhausted from motherhood's demands. And I'm not minimizing the difficulty of those days. They are *hard*. But only Jesus knows the fullest extent and fathomless depths of humility: "Consider him who endured from sinners such hostility against himself, so that you may not grow weary or fainthearted. In your struggle against sin you have not yet resisted to the point of shedding your blood" (Heb. 12:3–4).

But Jesus did.

In all his goodness, he left his rightful glory and came to earth. He did this so our hearts might be fundamentally and forever changed, so we might go from darkness to light and life, and so we might know the joy of becoming humble servants of Christ. He did this so

we might understand not just "going through the motions" love, but *incarnational* love.

Love that draws near.

Love that leaves behind whatever it has to.

Love that's so strong, it can't help but get into the world of the other person, no matter how low the stooping requires.

• • • —— • • •

Friend, he has not asked us to do something he has not already done. Jesus has gone before us in humility and service. He came down to us. Which means he is with you and me as we stoop down to our children in everyday life—wiping her tears, answering yet another one of his questions, reminding her of something you've already told her six times today, helping him with homework, kneeling to get on her level when she needs a tender glance.

Yes, Christ is with you in these moments because these things are the way of the Savior. Humility and incarnational love—this is the posture he takes with you and me. And more than simply being with you in the ways you serve, he changes you in the process—into something glorious.

But I'm getting ahead of myself.

I agree w/ so much of this book, but kw one thing gives me pause. I am picking up a tone of ALWAYS giving up our will for kids, and I don't think I agree that that is what's best for kids.

⚜BRING IT HOME

Meditate

Jesus is the only person who truly deserves to be served, but instead he came to serve you by becoming like you.

Reflect

In this chapter, we explored the stooping, incarnational love of Jesus. How would you explain that concept in your own words? When you are most struggling to assume a posture of humility and incarnational love toward your kids, how does it change things to remember that this is Jesus's posture toward you?

PRAY

Oh humble Jesus,

Thank you for willingly becoming flesh and dwelling among us. Thank you for lowering yourself to rescue a world that had rejected you, for giving grace where we deserve wrath. It is not easy or fun stooping to serve my kids; please help me consider how you, the God of all the universe, have stooped to serve me, even to death on a cross. Conform me into your humility, that it would be my joy and privilege to serve them as you have first served me. Amen.

PART 2

A Humble Servant

CHAPTER 3

He
Changes
You

Jesus answered him, "Truly, truly, I say to you, unless one is born again he cannot see the kingdom of God."

JOHN 3:3

EXTRA READING: John 3:1–21

How does a person change?

Many of our interactions with our kids involve changing a behavior. We teach them and correct them, only to see them revert back to the same patterns and responses, and we realize that no amount of behavior modification can get to the root of the problem: *the human heart*.

And it's not only our children who need to change; we do. We know that our role as mothers is a gift and a responsibility, and we love our kids—but we don't always enjoy the daily grind. We see attitudes within that discourage us, and attitudes from without that weary us.

Ironically, we don't always change in the way we expect our children to change.

Our hearts don't always reflect the work of our hands.

I can't speak for you, although I imagine you desperately want to change like I do. I get discouraged by my own impatience and my angry words. I get frustrated by my anxiety (particularly in the moments when a carefully laid agenda is thwarted!), my self-sufficiency, and my pride after a good day at home. I get weary from my quickness to see problems within everyone but myself.

How does a person change?!

This is what John wants us to see next.

• • • —— • • •

Thus far, the Light of the world has come into darkness. The Word at the beginning has willingly wrapped himself in human flesh and entered the womb of a woman, being born as a baby.

Then, slowly and over time, Jesus grows up. We can only imagine how even the mother of the Son of God knew short years full of long days.[1] Jesus is first a child, then a teenager, and finally, before Mary's eyes, he is an adult beginning his ministry.

[1] Although her child never sinned against her!

And apart from him coming into it, nothing in the world has changed.

The darkness still lingers since "people loved the darkness rather than the light because their works were evil" (John 3:19).

Notice the word *loved*.

Darkness and evil deeds are not simply some bad things we do, the results of unintentional missteps or provocation from other people. No—we are *drawn* to darkness. In its fallen state, the human heart loves what is evil. Isn't that a hard reality to swallow? Every human heart is controlled by, and held captive to, the power of sin. It is the water we swim in, and the air we naturally breathe.[2] Difficult as it may be to grapple with, it's true.

Since the heart is the seat of all our desires and motivations, if the heart is not right, nothing that proceeds from the heart will be right either[3]—not our motherhood, and certainly not our worship.

This was the wakeup call a man named Nicodemus desperately needed.

$$\cdots \; \rule{1em}{0.4pt} \; \cdots$$

He was a man of the Pharisees and a ruler of the Jews (John 3:1), an accomplished religious authority. After decades of applying himself to study and teach Old Testament law—something Nicodemus never questioned, something that was ingrained in him as right and good from childhood—his world was turned upside-down.

By a carpenter named Jesus.

Nicodemus wasn't at the wedding in Galilee, but he heard about how Jesus had turned water into wine there. And he was there in the temple after the man had caused such a commotion that many of his Jewish colleagues came running to settle the situation.

And he wasn't sure what to make of it all. Of *him*.

[2] Dane Ortlund, *Gentle and Lowly: The Heart of Christ for Sinners and Sufferers* (Wheaton, IL: Crossway, 2020), 175.

[3] Proverbs 4:23; Matthew 15:18; Mark 7:20–23

Whether out of genuine desire to understand (and maybe even believe) this zeal-filled, miracle-working man, or on an errand for the Pharisees to evaluate and squash a potential threat among the people, Nicodemus was done wondering. He had to find out for himself.

So, one night, he ventured out. The closer he got to where Jesus stayed, the higher his nerves rose. What would the townspeople think if they saw him conversing with this trouble-maker? They could never know. It would be their secret.

As he approached the house where Jesus was staying, Nicodemus noticed a small fire burning and a man warming his hands. It was him. Jesus lifted his head, met his eyes, and smiled.

It was like the man knew he was coming. *No turning back now.*

· · · — · · ·

I love Nicodemus's story. He was a Bible teacher serving God and God's people, seeking to uphold the law and walk in God's ways. He was hardworking, devoted, and authoritative.[4]

Sounds like a lot of moms I know.

Unlike many other religious leaders, Nicodemus was curious about Jesus, but he carefully hid his curiosity in the darkness of a night visit (John 3:2). Since Jesus "knew all people" and "knew what was in man" (John 2:24–25), none of Nicodemus's desires, doubts, or questions would have been hidden from the Light of the world, not even the ones shrouded in spiritual darkness.

Still, Jesus draws him and receives him.

What a wonderful reality for us to take to heart. For all the darkness and desperation in the human soul, *Jesus warmly receives all those who humbly come to him.* His interaction with Nicodemus

[4] I appreciate my senior pastor's helpful profiling of Nicodemus in his sermon on this passage. His whole series "Meet Jesus" is well worth listening to. See Colin Smith, "When Religion Misses the Point." *Unlocking the Bible* (March 6, 2016), accessed December 2020, https://unlockingthebible.org/sermon/when-religion-misses-point.

reminds us that his eyes and ears are open to the humble in spirit. "For though the LORD is high, he regards the lowly" (Ps. 138:6).

So Jesus receives the curious Nicodemus, who identifies him as a "teacher come from God." The Pharisee knows God is with Jesus in a unique way (John 3:2), and who wouldn't want to learn from a great teacher, especially one who does miracles? Don't we also want wisdom and understanding and *miraculous help* from God as we raise our children?

But Jesus's words will catch us off guard, as it did the Pharisee: "Truly, truly, I say to you, unless one is born again he cannot see the kingdom of God" (John 3:3).

Wait—Nicodemus wasn't asking Jesus about how to get to heaven. Where did this come from?

• • • —— • • •

It isn't as far out of left field as we may think.

Jesus is adjusting the Pharisee's assumptions about who he is: *I am far more than a teacher.* He is also adjusting his assumptions about how a person changes: *You cannot work your way into righteousness or favor with God.*

A teacher of Old Testament law, Nicodemus would have been seeking the kingdom of God—eternal life under the Creator's kingship—by diligently following God's commands. And while obeying God's ways is a good and admirable pursuit, it couldn't save him.

And it can't save us.

No amount of law-abiding can make a dead and darkened heart beat.

Ephesians 2:1–3 gives a vivid description of the state of our hearts apart from God's divine intervention: dead, following Satan, children of disobedience and wrath. Apart from him, a power stronger than us rules us, and no combination of good, diligent attempts to change can overrule this power.

Just like behavior modification won't change our kids' hearts—the seat of their affections and source of their actions—it won't change our hearts either.

Trying to be a good mom won't make us a good mom.

If the problem is within us, then what we need is a fresh start—and a new heart.

This is what Jesus graciously offers to Nicodemus: "Truly, truly, I say to you, unless one is born again he cannot see the kingdom of God." In essence, Jesus is saying this: *Nicodemus, you think that I am a great teacher, and I am. But I am also more than a great teacher. I have come to offer you more than instructions for how to live a good life; I have come to offer you my very life, my goodness. To make you not merely decent, but new. I have come to do for you what you cannot do for yourself.*

Jesus has come to do for you, friend, what you can't do for yourself.

He has come to change your heart.

· · · —— · · ·

Remember our hypothetical situation: What if your newborn baby insisted that he or she had done all the work in being born? Babies are helpless. Birth involves the baby, but it isn't a result of the baby's initiative. The baby is simply the happy, blessed recipient of life.

So it is with us.

Through God's astounding love for the world he made, he initiated a rescue mission for dead hearts. If we are to change—if we are to see our hearts fundamentally renewed—we must lay aside our exhausting attempts to be "mom enough" and receive his provision for us: "For God so loved the world, that he gave his only Son, that whoever believes in him should not perish but have eternal life" (John 3:16).

Jesus was born to die so we might be born again.

He was lifted up on a cross to bear the penalty for our hardheartedness, for our selfishness and sin, and for the darkness within us (John 3:14–15). He was lifted up to make good on the promise of

rescue and renewal God had made to his people in generations past. What was that promise? "And I will give you a new heart, and a new spirit I will put within you. And I will remove the heart of stone from your flesh and give you a heart of flesh" (Ezek. 36:26).

The Word *became flesh* to make this promise a reality for his people. As Dane Ortlund says, "Christ was sent not to mend wounded people or wake sleepy people or advise confused people or inspire bored people or spur on lazy people or educate ignorant people, *but to raise dead people.*"[5]

Jesus's heart is to serve his own by making us *alive.*

This is really good, freeing news for us, Mom. It means we can't possibly be, in all our valiant efforts, the Rescuer and Renewer of our kids' hearts. We can be consistent with discipline and instruction, and might even see some immediate behavior changes, but *we can't produce lasting heart-change.*

Only Jesus can get to the root of the problem.

Only Jesus can make our kids alive.

Do you see how this changes things? Instead of being high-and-mighty moms who wag our fingers at our kids, confused and frustrated that they keep getting it wrong, we will be moms on our knees, humble and prayerful, as we plead for Jesus to do what only he can do.

We will be realistic moms as we discipline and instruct our children, knowing that no amount of behavior modification can change the heart.

We will be compassionate moms who understand our kids' biggest problem since it's *our* biggest problem too.

And we will be hopeful moms who tell them the good news about the Heart-Changer who's in the business of rescuing sinners.

. . . —— . . .

[5] Ortlund, *Gentle and Lowly,* 175. The added italics are mine.

So, how does a person change? How do *we* change?
We can't. Not on our own initiative, at least:

> Nicodemus said to him, "How can a man be born
> when he is old? Can he enter a second time into his
> mother's womb and be born?" Jesus answered . . .
> "The wind blows where it wishes, and you hear its
> sound, but you do not know where it comes from
> or where it goes. So it is with everyone who is born
> of the Spirit." (John 3:4–5, 8)

Jesus is telling us there is hope for change through divine interven-
tion. Through his Spirit's gracious ministry, we can be wholly remade
and completely renewed, brought from darkness to light, cleansed of
sin, and given new affections, new desires, new motivations—a fresh
start, and a new heart.

Perhaps you've not clearly heard his invitation until now, friend. It
is a beautiful one: Jesus invites you to lay aside your weary attempts to
be mom-enough, to simply admit you *can't* be good enough for God
or your family in your own strength. He invites you to cast yourself
upon him instead—on his goodness and help and ability to change
you. He invites you to believe in him and receive the gift of new life,
an eternally beating heart that above all delights to serve him.

Perhaps you trusted Jesus a long time ago, but your incessant
failures and sin-patterns have taken a toll and made you doubt his
patience: the angry outbursts, the despairing thoughts, the desire
to escape your kids, the underlying feeling of discontentment, the
looming cloud of shame over your failures.

*Jesus knows all of that, and he came to you so you will contin-
ually come to him.*

Your inability to change on your own efforts doesn't make him
scoff at you in disdain and disappointment (how we sometimes
respond to our kids).

Instead, your need for him stirs his longing to help.

This is who Jesus is: a humble servant, come to do his Father's will, to rescue his people, and to fulfill his Father's promise by giving us new hearts.

And as we'll see in the pages ahead, out of these new hearts, he promises us, will flow rivers of living water.

BRING IT HOME

Meditate

Jesus's heart is to serve you by making you alive, and your (and your kids') desperate need for lasting, eternal heart-change stirs his compassion to help.

Reflect

How does Jesus's heart-changing ministry alter both your expectations and your goals for yourself and your kids?

PRAY

Lord Jesus,

There are so many times when I feel discouraged by my own inability to change and by my kids' inability to change! But you know this, and you change people. Work in my heart by your Spirit, and make me a humble mom who doesn't hide my need for you, fearing that you're frustrated by me. Instead, help me believe that you want me to bring that need before you. Help me abandon my attempts to be mom-enough or change my kids in my own strength. Do within my kids' hearts what only you can do, and use me as a messenger of your good news, that you rescue sinners and make us alive. Thank you for warmly receiving all those who humbly come to you, that my eternal need stirs your longing to help. Amen.

CHAPTER 4

He
Satisfies
You

Jesus said to her, "Everyone who drinks of this water will be thirsty again, but whoever drinks of the water that I will give him will never be thirsty again. The water that I will give him will become in him a spring of water welling up to eternal life."

JOHN 4:13–14

EXTRA READING: John 4:1–42; 7:37–39; 7:53–8:11

A friend once told me about her neighbor's month-long birthday celebration.

She was a mom of young children and, as I'm sure you can imagine, was juggling their wants and needs while laying aside her own. When her birthday rolled around, she decided that it was her turn, time for her wants and needs to be met, so she declared the next month *hers*.

To be fair, that's all I know about this story; I have no idea how she ended up celebrating herself the next thirty days. Maybe it was fantastic. But what I suspect is this: that no matter how much time she spent away from her kids, how many fun things she did or people she saw or gifts she gave herself, she probably wasn't completely satisfied.

She was probably left thirsty for more—a lot like the woman at the well.

· · · — · · ·

This infamous woman in John 4 was a Samaritan, and a female nonetheless. To top it off, she was living in sin—having been in marriages to five different husbands, all of which had dissolved, leaving wounds and insecurities and in all likelihood, deeply entrenched bitterness. And now she was sleeping with another man who is not her husband. He wasn't all bad, but the situation certainly wasn't good. And it wouldn't last long, that she knew.

Her shame ran deep.

Thirsty.

So at noon she went to the well. The sun was hot that time of day, but at least she wouldn't be bothered, whispered about, judged.

Oh fabulous. Someone is already here.

A man sits on the well's edge, looking thirsty and worn. He is alone. He looks up and sees her, but he doesn't turn his face from her or move in the opposite direction like most men do (unless they want something from her).

Instead, he speaks. "Give me a drink."

She is shocked into silence. This man isn't from town. No, he is clearly one of them, a Jew, who for some reason had traveled through Samaria, rather than avoiding it by way of the sea. After a moment, she gathers the courage to respond. "How is it that you, a Jew, ask for a drink from me, a woman of Samaria?"

Why is he here? And why is he talking to me?

Jesus answered her, "If you knew the gift of God, and who it is that is saying to you, 'Give me a drink,' you would have asked him, and he would have given you living water" (John 4:10).

• • • — • • •

Our journey through John's Gospel continues as we seek the humble heart of Jesus. After focusing on the creation of all things by the Word, and then his dwelling among us in human form, John transitions into Jesus's earthly ministry, the fleshing-out of his humble heart toward his people. And John's flow is strategic: by the Holy Spirit's guiding inspiration, he places side-by-side two polar-opposite people and their interactions with Jesus.

There's Nicodemus, the upstanding, devoted teacher of the Jewish law, who seeks Jesus by night (John 3). And there's the Samaritan, a woman culturally disdained by Jews, with messed up relationships and a confused religion, whom Jesus seeks in broad daylight (John 4).

A religious man, and an unclean woman.

The most admirable among society, and the most marginalized.

Both of whom were sinners, needing new hearts.

Both of whom were warmly received by Jesus.

You may be more like Nicodemus, momma—a "good," moral person raised in a Christian home, a devoted church member, eager to teach your kids the truth—or you may relate more to the Samaritan woman, perhaps because of a rough family history, an unfamiliarity with the Scriptures, or an uncertainty over how to break free of unhealthy patterns.

Jesus shows no partiality, but seeks you right where you are, right now.

Our human reasoning would expect Jesus to interact with Nicodemus, but not with the Samaritan woman; yet God does not typically do what we expect. John comments that "Jews have no dealings with Samaritans" (John 4:9). Why not? During the Assyrian invasion of Samaria in 722 BC, some Israelites were exiled while some remained in the city. The ones who remained were married to foreigners and were no longer considered the pure people of God. Even their place of worship was different than the Jewish temple in Jerusalem.

So this woman is not only living in sin, but she is also what the Jews considered an ethnic and religious half-breed. Impure. Contaminated. She is the kind of mixed-blood person they—especially their religious elites—would have taken great pains to avoid.

Yet Jesus—the Son of God, the Word made flesh, holiness incarnate, and a Jew—does exactly the opposite, and he surprises us with his lowliness.

D. A. Carson calls this the "sheer flexibility of Jesus."[1] No personality, no religious background, no family history or generational sin, no uncleanness, no need or longing is too burdensome for him. The only thing that qualifies us for Jesus is *our lack of qualifications*, our humble position of need before him. And the only type of person whom Jesus refuses to help throughout his ministry (as is often seen in John's Gospel[2]) is the one unwilling to recognize their needy position.

It's worth considering right now how you and I are like this woman.

You may not have a string of five men in your history, or maybe you do. You may not be a cultural outcast, or maybe you are. Regardless, we all know that sense of longing for more. We've all experienced how quickly feelings of happiness and contentment wear off, how no

[1] D. A. Carson, *The Gospel According to John* (Grand Rapids, MI: Wm. B. Eerdmans, 1991), 221.

[2] See John 5:37–47; 6:41–71; and 7:1–24 as a few examples of Jesus's attitude toward prideful people.

amount of retail therapy or indulgences or me-time or "well-dones" can give us the true satisfaction we thirst for as moms.

We know the desire to escape from our circumstances, from our kids, from our history, from ourselves. We know the lingering suspicion that we just aren't doing this mom-thing right, and the shame from our repeated failures toward our children. Even after an ideal day with our kids, we know how our heads hit the pillow wondering, *Is this really all there is for me? This should have filled me up—why do I still feel so empty?*

No, we are not unlike this woman. Every single one of us has a string of something behind us, reminding us of our shame and failure. Every single one of us knows what *empty* and *thirsty* feel like after trying so hard to be satisfied. And Jesus's sheer flexibility extends even to us.

· · · —— · · ·

> Jesus said to her, "Everyone who drinks of this water will be thirsty again, but whoever drinks of the water that I will give him will never be thirsty again. The water that I will give him will become in him a spring of water welling up to eternal life." The woman said to him, "Sir, give me this water, so that I will not be thirsty or have to come here to draw water." (John 4:13–15)

The woman simply does not realize who stands before her. She thinks he is offering her running water of another source so she will not need to make daily trips to Jacob's well. She thinks he is speaking of convenience, of material need, of practicality and ease.

But *God himself* stands before her, and he offers her something infinitely more satisfying, something to meet her greatest need and deepest thirst. If she had realized this was God in the flesh, how could

she not have asked him for *everything*? How could she have held anything back?

Similarly, how often are we content with temporary means of satisfying our thirsts? And how often is the Son of God, in all the riches of his grace, right in front of us, ready to serve us living water—a free gift! ours for the taking!—yet we so often choose convenience and opt for ease, striving in our own strength, only to find that these replacements don't last and can't possibly quench our craving. We hear echoes of the Samaritan woman's request in our own:

> *Give me social media so I will not be lonely.*
>
> *Give me praise so I will not be undervalued.*
>
> *Give me opportunities so I will not feel useless.*
>
> *Give me obedient children so I will not be inconvenienced.*
>
> *Give me another purchase online so I will not be without.*

Now, social media and praise and well-behaved kids and shopping are not inherently evil. "A person cannot receive even one thing unless it is given him from heaven" (John 3:27). Every good gift, every enjoyment, every benefit comes from God, so these are not bad things in themselves—far from it. *But we can't expect these gifts to give us what only Jesus can.* When we do, we heap upon them burdens they were never meant to bear and, in doing so, we heap unnecessary weight upon our disappointed selves.

And worse—we often break under the pressure.

Or in Jeremiah's imagery, we thirst and thirst and are never satisfied:

> "Be appalled, O heavens, at this;
> be shocked, be utterly desolate,
> declares the LORD,
> for my people have committed two evils:
> *they have forsaken me,*

> *the fountain of living waters,*
> *and hewed out cisterns for themselves,*
> *broken cisterns that can hold no water."*
> (Jer. 2:12–13, italics added)

I've watched my daughter get frustrated at the beach when she fills up her special sand bucket only to realize there are holes in the bottom (why?!), and all the water has slowly trickled out. She ends up having to refill the leaky bucket again and again, to her exhaustion and perpetual disappointment.

Our experience can be like this sometimes on the soul level, can't it?

God created us to thirst for him, to be in right relationship with him; but when sin darkened our hearts, we "exchanged the truth about God for a lie and worshiped and served the creature rather than the Creator" (Rom. 1:21, 25). We chose to forsake the fountain of living waters and instead ran after cheap, holey imitations, none of which could meet our soul's greatest need and sustain its highest joy: eternal life loving and serving our Maker.

Within our hearts, thirst and worship are connected.

Whatever we thirst for, we will worship. And whatever we worship, that we will thirst for.

$$\cdots \, \text{—} \, \cdots$$

Just as Jesus sought the Samaritan woman, he seeks us so we will worship him.

> "But the hour is coming, and is now here, when the true worshipers will worship the Father in spirit and truth, for *the Father is seeking such people to worship him.* God is spirit, and those who worship him must worship in spirit and truth." (John 4:23–24, italics added)

Remember why Jesus came? To change our hearts. To reorient our worship. To quench our thirst and satisfy our longing souls with himself.

Through the power of his Spirit (whom we will focus on later), Jesus regenerates our hearts and rights our worship, and we are given new desires so we will thirst for him above everything else. When Jesus says that those who drink of him will never be thirsty again, he isn't saying that our longings will instantly disappear, but that he will *always, always* be there, not only to meet us in our longings, but to fill them up.

For every thirst we have, he promises to satisfy us with himself.

I love John Piper's summary of Jesus's words: "I have the water of life. You have thirst. And you need what I have to live. If you will drink—if you will believe on me as your ever-satisfying treasure—you will live forever."[3]

No matter where you have come from, Mom, and no matter how many times you have chosen broken cisterns over his never-ending, overflowing fountain, Jesus invites you to drink deeply of him: "If anyone thirsts, let him come to me and drink. Whoever believes in me, as the Scripture has said, 'Out of his heart will flow rivers of living water'" (John 7:37–38).

Anyone. Whoever. Come to me.

No bad day of motherhood, no angry meltdown toward your kids, no attempts to escape from your circumstances, no wayward worship or mishandled thirst will shut off the fountain of rich mercy and grace that is in Jesus. Quite the opposite: your thirst for him causes his plentiful provision and lavish grace to overflow to you exactly when you need it.[4]

[3] John Piper, "You Will Never Be Thirsty Again," *Desiring God* (June 14, 2009), accessed January 2021, https://www.desiringgod.org/messages/you-will-never-be-thirsty-again.

[4] I love how Dane Ortlund describes this: "Our sins cause his love to surge forward all the more." *Gentle and Lowly: The Heart of Christ for Sinners and Sufferers* (Wheaton, IL: Crossway, 2020), 180.

What is the longing of Jesus's heart? To satisfy us in our deepest longings so we will long for and worship him.

This gives us pause to examine ourselves and ask, How often do I view Jesus warily, like the woman did? *He can't possibly want to help me. I've messed up so much and been so weak and needy and failed yet again—and it's only been an hour since I got out of bed! How frustrating for him.*

I think we often hesitate to come to Jesus and receive from him for two main reasons: (1) we aren't really sure that he can provide; (2) we aren't really sure he wants to.

Let Jesus's encounter with this woman convince you: *He loves it when you come to him and drink of him, for he is perfectly able to satisfy your longing soul.* This is why he came. He is not like us, who get annoyed at our kids when they come to us with their wants and needs over and over. No, he seeks us out and welcomes us. He longs to satisfy our thirst. Again and again.

When you thirst for affection today, drink deeply of his perfect love.

When you thirst for praise today, drink deeply of his good pleasure.

When you thirst for help today, drink deeply of his daily mercies.

When you thirst for adult company today, drink deeply of his faithful friendship.

When you thirst for rest today, drink deeply of his unceasing strength.

As the Samaritan woman did, let the walls come down—refuse to resist him any longer or believe that your needs and longings must be the exception—and come to him and drink. Believe that he longs to satisfy you, and then let him do it.

There are many ways he does this, and this is what John will show us next.

BRING IT HOME

Meditate

For every thirst you have, Jesus
invites you to drink deeply of him and
promises to satisfy you with himself—
he won't ever turn you away.

Reflect

Do a heart-check on your posture toward
Jesus: Do you view him warily, unsure
if he wants to provide for you? Does
this make you hesitant to come to him?
Or are you convinced of his longing
to provide for your every thirst?

PRAY

Living Water,

You satisfy the weary, longing soul (Jer. 31:25), no matter what string of failures lie in their wake. No one is too good to need you, and no one is too far to have you. I need you, and I thirst for you every day. I'm sorry for trying to satisfy my deepest longings with anything other than you, Jesus. Help me turn to you when I'm weary instead of turning to worldly things that can't ultimately satisfy me. Help me have a right view of who you are: a welcoming, good, and gracious Savior, able to fill me up when I've been leaky, empty, and overwhelmed. The next time my kids come to me needing or wanting something, give me your humble heart to receive them as you receive me, meet their needs as you do mine, and pour out the love you've filled me with. In your name I pray, amen.

He
Provides
for You

Jesus said, "Have the people sit down."

Now there was much grass in the place. So

the men sat down, about five thousand in

number. Jesus then took the loaves, and

when he had given thanks, he distributed

them to those who were seated. So also

the fish, as much as they wanted.

JOHN 6:10–11

EXTRA READING: John 6

"Your levels are looking good. The doctor says you can start trying."

For a moment, I couldn't speak. "Wait . . . really?" I said to the nurse. "He thinks I'm in a good spot?" She affirmed my question, and I thanked her and hung up the phone. Wide-eyed, I went into the next room where my husband was sitting.

"The nurse called and gave us the go-ahead."

The two of us were elated, and I remember crying and hugging my husband. I remember us praying and thanking God for healing.

And I remember the instantaneous fear.

Would I even be able to carry a child, with my history?

And if I could, how would I care for a baby when I was struggling to care for myself?

• • • —— • • •

Motherhood introduces us to realms of weakness we might never have otherwise known. From the moment the pregnancy test reads positive and a little life inhabits our womb, we embody one of the most intimate forms of hospitality, and our limitations loom large. Many of us begin by worshiping the porcelain goddess or struggling to keep our eyes open throughout the day; and even if we avoid these symptoms, every mother knows the sinking feeling of not being in control.

We know the outcome is entirely out of our hands.

Our story above is one example of this. For years I battled Lyme disease without knowing it, and when I was finally diagnosed by a doctor, the road ahead was scary.[1] We didn't know how my immune system would respond to treatment, so the doctors cautioned us not to grow our family, at least not yet. For six years, I dealt with chronic

[1] You can read more about my Lyme disease journey in *Hope When It Hurts*, a book I cowrote with my friend, Sarah Walton, about how God meets us in suffering. I also wrote a book on fear and the promises of God called *Fight Your Fears*, in response to the many fears I've battled in the last decade.

pain, fatigue, and muscular weaknesses that made it hard to function, so the idea of having a baby seemed impossible.

When the nurse called to tell me my immune system markers were indicating health and that we could try for a family, I was overcome with gratitude—and nervousness. The green light meant more risks, more questions, and an equally unknown future.

Would God provide for us?

I wonder what causes you to ask this question:

When you wake up in the morning already drained from a night of feedings . . .

When your toddler starts resisting his afternoon nap . . .

When your whole family comes down with the flu . . .

When everyone is crying at once . . .

When your monthly expenses exceed your income . . .

When you endure another miscarriage . . .

When another adoption fails or your foster child rejects you . . .

When chronic pain makes its home in your body . . .

When tragedy tears your heart in two—

Will God provide for you? Does he even want to?

John's next account demonstrates how Jesus's answer is undeniably, resoundingly *yes*.

· · · — · · ·

The Son of God's popularity is increasing. The people have seen his miracles and are intrigued. They watched him transform water into wine at a wedding feast (John 2:1–11), heal an official's son with words from his lips (John 4:46–54), and restore a lame man's ability to walk (John 5:1–17). Some people, however, are furious with jealousy and incensed against Jesus: "This was why the Jews were seeking all the more to kill him, because not only was he breaking the Sabbath, but he was even calling God his own Father, making himself equal with God" (John 5:18).

Jesus's fourth miracle takes place against this mixed landscape.

Matthew, Mark, and Luke's Gospels tell us how his disciples had just come back from a busy ministry season. They had been healing diseases, exorcising demons, and preaching,[2] and they must have been exhausted. So Jesus takes them up on a mountain, what Mark calls a "desolate place" (Mark 6:31), and tells them to rest a while and recover. He knows their limitations, that they can't run at such a pace forever. They need a break:

> After this Jesus went away to the other side of the
> Sea of Galilee, which is the Sea of Tiberias. And a
> large crowd was following him, because they saw
> the signs that he was doing on the sick. Jesus went
> up on the mountain, and there he sat down with
> his disciples. (John 6:1–3)

How many of us long for a desolate place after an extra-tough morning with our kids or busier-than-normal week? (We'll even welcome the desolate place called our bathroom if it means being alone for one beautiful moment.) Take comfort in this: *Jesus knows your limitations because he was also limited.* When the Word of God became flesh, he was "made like his brothers in every respect" (Heb. 2:17). Just as you and I "share in flesh and blood, he himself likewise partook of the same things" (Heb. 2:14a). Being hemmed in by a physical body that underwent the same kinds of weaknesses and temptations as yours and mine (Heb. 4:15), Jesus knew what it was to be tired, hungry, and weary.[3]

So in this moment, he knew what his disciples were feeling.

And in our depleted moments, he knows what we're feeling too.

Added to this, *Jesus knows your limitations because he created them.* Far from what we think and want to believe, our limitations are God-given. They are not mistakes, but are tailor-made by our Creator. True, some of our weaknesses are linked to sin and suffering; my chronic pain from Lyme, for example, is one effect of a creation

[2] See Luke 9:1–2.
[3] We also know he never ceased being fully God, which is mind-boggling.

diseased by sin. But many of our limitations are God-designed and intentionally given to us. Why? So we will know, without a doubt, how much we need him, which is the best place we can be. Consider some of your limitations and how these expose your need for the Limitless One:

We need sleep; God never shuts his eyes (Ps. 121:4).

We can only be in one place at a time; he is everywhere present, always (Ps. 139:7–12).

We don't always have the depth of understanding or the answers we need to help with our kids' problems; God perfectly searches our hearts (Ps. 139:1) and is the definition of knowledge, wisdom, and understanding (Job 12:13).

We can adequately handle one or two of our kids' needs at once (maybe three, if we've had enough practice); he is upholding the entire universe, right now, by simply speaking (Heb. 1:3) and is actively caring for all his creation (Ps. 145:16) while making sure every single one of his plans comes to pass (Isa. 55:10–11).

Take comfort, friend, because Jesus knows your limitations. He created many of them, and he experienced them himself, in his own body. He is not surprised or embarrassed by them like you are, nor will he waste a single one.

Instead, your weaknesses and limitations are exactly the kind of raw material he loves to work with.

· · · —— · · ·

Jesus's response to the crowd takes us aback:

> Now the Passover, the feast of the Jews, was at hand. Lifting up his eyes, then, and seeing that a large crowd was coming toward him, Jesus said to Philip, "Where are we to buy bread, so that these people may eat?" He said this to test him, for he himself knew what he would do. (John 6:4–6)

Although his planned retreat with his disciples has been thwarted, Jesus doesn't react in frustration or ignore the crowds, nor does he begrudgingly proceed. No—he is not like us. He always *wants* to do what his Father wants. This desire is as natural for him as it is for us to want our own way. What motivates Jesus above all else is a desire to please his Father: "My food is to do the will of him who sent me and to accomplish his work" (John 4:34). "I seek not my own will but the will of him who sent me" (John 5:30).

The Son's agenda can never be interrupted because it is the same as his Father's.

He has no category for disruptions.

Doesn't that sound like freedom? What a beautiful thing for us as mothers to ask of him when we are struggling to lay down our plans: *God, align my heart with yours. Make my desires your desires, and my agenda the same as yours.*

Since Jesus's will is to do his Father's will, when he sees the crowd approaching, he doesn't turn them away but receives them. This both reassures us and challenges us: we can come needy to Jesus trusting he will not turn us away, and when our children come needy to us, we have an opportunity to receive them as he has received us.

For Jesus is drawn to the humble one. The one with a lot of needs.

He will have compassion on us because this is what most readily pours from his heart.[4]

So when Jesus sees the crowd approaching, he *feels* for them. They are in a desolate place, a wilderness of sorts, a place that Jesus himself knew when he went without food and was tempted by the devil for forty days. And when you are in a place of need, even a place of outright misery, Jesus's heart fills with compassion for you because he too knew that place of weakness when he walked the earth.

[4] Compassion is the word Matthew and Mark use to describe Jesus's response to the people. I am indebted to Dane Ortlund's book, *Gentle and Lowly: The Heart of Christ for Sinners and Sufferers* (Wheaton, IL: Crossway, 2020), that meditates so beautifully on this truth.

When a mom reaches out to a friend for help and prayer, or maybe because she just needs a listening ear, a common response from the other end of the phone is, "I feel you, sister."

I get you. I'm in it too. I feel your pain and know your burdens.

When we come to Jesus, he says, "I feel you" in the most genuine way.

His compassion is perfect; it is never tainted by judgment or selfishness like ours is; it is never restricted or held back. No, he is divinely, mercifully, wholly drawn to the needy.

It's the reason he came. His arms are wide open to us.

So how could we not go to him?

· · · ▬ · · ·

When your limitations reach Jesus's compassionate heart, what pours out is grace, the lavish generosity of God for the weak and weary:

> One of his disciples, Andrew, Simon Peter's brother, said to him, "There is a boy here who has five barley loaves and two fish, but what are they for so many?" Jesus said, "Have the people sit down." Now there was much grass in the place. So the men sat down, about five thousand in number. Jesus then took the loaves, and when he had given thanks, he distributed them to those who were seated. So also the fish, as much as they wanted. (John 6:8–11)

When Jesus multiplied the loaves and fish, he was echoing a bygone era.

For forty years, God's people wandered through the wilderness after their exodus from Egypt, and God supplied them enough food for every day and each person: "Then the LORD said to Moses, 'Behold, I am about to rain bread from heaven for you, and the

people shall go out and gather a day's portion every day, that I may test them, whether they will walk in my law or not'" (Exod. 16:4).

Notice two things here about grace.

First, God is gracious to test us and increase our dependence on him. God's words to Moses are similar to his intention before the crowds: "[Jesus] said this to test him" (John 6:6). Our needs and weaknesses are often tests of faith. We wonder along with the disciples, *What are my limited resources for so many needs?* The true question is, *How might God want me to see and depend on and experience his limitless grace in this moment of need?*

It's easy to think that God is being gracious to us when he gives us what we want (#blessed). But what about when God gives us what we *don't* want, even when it's what our hearts most need—even when it's hard—so we will learn to hunger for him and desire his agenda above all else? *This* is the humble kindness of God—this is grace—not to give us what we want, but to give us what he knows we most need. And whatever he gives comes from the heart of a loving, servant-hearted God with a perfect agenda for us.

Second, God is gracious to give us exactly what we need. Notice how God promised Moses and the people "a day's portion [of manna] every day." God had just miraculously parted the Red Sea to deliver his people from slavery in Egypt—and now they are worried about food. This was their tendency, and it's ours too. With incredible needs looming large in the tiny little people before us, we tend to forget about the big picture. We forget what God the Son has already done and how he has already cared for us:

> "I am the bread of life. Your fathers ate the manna in the wilderness, and they died. This is the bread that comes down from heaven, so that one may eat of it and not die. I am the living bread that came down from heaven. If anyone eats of this bread, he will live forever. And the bread that I will give for the life of the world is my flesh." (John 6:48–51)

The gruesome death the religious leaders are plotting is coming, when Jesus will lay down his life for his people. And if he gave his life to give us himself for eternity, can we not depend on him to give us what we need for today?

BRING IT HOME

Meditate

When your limitations reach Jesus's compassionate heart, what pours out is grace, the lavish generosity of God for the weak and weary.

Reflect

How would your approach to Jesus change if you trusted his compassion to provide for you in moments of great weaknesses and limitation?

PRAY

Provider God,

You created me to need you, and that is the best position to be in since you are full of grace (John 1:14). Thank you that you did not spare your own Son but gave him up for my greatest need. I know that I can trust you for every other need. Whatever you give today is *grace* because it comes from your loving heart and perfect agenda. When I hesitate to draw near to you in my weakness, help me remember how Jesus's compassion for me is rooted in his experiential grasp of what it is to be human. Give me what I need today to serve my kids, and help me trust that what you give is enough. In Jesus's name, amen.

He
Leads
You

"I am the good shepherd. I know my own and my own know me, just as the Father knows me and I know the Father; and I lay down my life for the sheep."

JOHN 10:14–15

EXTRA READING: John 7:25–31, 40–52; John 10

We've made it through the first half of John's Gospel.

Is Jesus who you expect him to be?

How could the Word at the beginning—God the Son enjoying idyllic harmony with God the Father and God the Spirit—willingly enter into his creation that had rejected him, knowing this would happen again? How could the high and holy One of heaven lower himself to the dust of earth and wrap himself in flesh with all its limitations, all its pains? How could his perfect, sinless heart be drawn in perfect compassion to sinners—to you and me?

How could the exalted God and Savior of the universe be so *humble*?

As we come to grips with this, our instinctive view of God is challenged. By "instinctive," I mean that there's a wariness in each one of us that questions his heart, a suspicion that goes, *Sure, Jesus loves me, but he must not like me all that much. I'm such a mess.*

It's similar to how we sometimes feel toward our kids. We love them—we would do anything for them—but man, in some moments, we struggle to like them.

If we've learned anything from John, though, it's that Jesus is not like us.

He isn't who we often expect him to be.

And he wasn't what the people around him expected him to be either.

· · · —— · · ·

"Rabbi, you are the Son of God! You are the King of Israel!" (John 1:49)

"This is indeed the Prophet who is to come into the world!" (John 6:14)

"He has a demon, and is insane; why listen to
him?" (John 10:20)

Throughout John's Gospel, opinions about Jesus are broad-ranging. *Is he a good teacher, or an insane person?* Some confessed
Jesus as "the Christ," which means the same thing as *messiah*,
God's anointed king who would reign over God's people. Anticipated
in the Old Testament, the Messiah would be a ruler to right every
wrong, uphold God's promises, and lead God's people into rest from
all their enemies.

He would be the definition and fulfillment of a great leader.

John wants us to see and believe that Jesus is indeed the Messiah,
the Christ; that's the whole aim of his Gospel (John 20:31). But John
also wants us to see how different a king Jesus is than what we would
expect, than what the world is typically drawn to.

He is a king—and a servant. He is a ruler—and a shepherd.

For he did not come in power and forcefulness, but in meekness and mercy. The start of his messianic rule wasn't a ruthless
elbow-throwing climb to the top, but a willing descent to the very
bottom.

Jesus is an unexpected king, for he is a good and tender
shepherd-king.

And the greatness of his leadership is reflected in his lowliness, his
humility.

• • • — • • •

What makes a great mother?

Is greatness about raising good kids who get good grades and
eventually good jobs? Does it mean your kids follow Christ, and if
they don't, that your mothering somehow failed? Is it about managing your children until they're gone and you can't control them
anymore?

Maybe it's about finding your "other thing"—your side hustle—and becoming an expert at it, either within the home, outside the home, or on Instagram . . .

Or perhaps it's about indulging in our vices every now and again, or becoming true to ourselves by listening to the voice within. Maybe it's learning how to unhitch ourselves from everyone's expectations in order to find true happiness.

Some of these ideas are taken from books written for moms, and they reflect the world's definition of greatness: power, influence, and self-actualization. But Jesus defines greatness like this: "whoever would be great among you must be your servant" (Matt. 20:26).

Greatness is not about puffing ourselves up, but laying ourselves down.

It is not only about what we're doing, but *why and how* we're doing it.

It is the humble posture of the heart.

Now, this doesn't mean we can't pursue other interests or want to grow in various skill sets or intentionally pull away sometimes to rest—far from it. But remember that our hearts motivate our hands, and it is a *heart-posture of humility before Jesus that makes a mom truly great.*

Jesus's messianic rule is (and was) great because it is motivated by sacrificial servant-leadership, a heart-posture of humility toward us. What a breath of fresh air for overwhelmed and wayward mommas who are jaded by the abuse of power around us, who find it natural and easy to be self-interested, who often have *no idea* what we're doing but are expected to pretend like we do.

In a world full of noise, we need a sure and steady voice to cut through it all.

We don't need a dictator who makes demands, but a refuge in whom we can rest.

We need someone we can trust to lead us as we lead our kids.

We need a *good* shepherd with a humble heart.

· · · — · · ·

Jesus raises his hand and says, "I am that shepherd."

As you think about the whole of Scripture, does the word *shepherd* ring any bells? Remember that God's people were waiting, all throughout their history, for their Messiah-King to come—but with the coming of every new leader came disappointment. We think about King David, the shepherd boy whom God had anointed king, who said, "The LORD is my shepherd" (Ps. 23:1), knowing he could not shepherd God's people apart from God's help. Then, in the next breath, we think about Saul (who came before David), whose reign started well but ended in disobedience, self-pity, and a failure in his role as Israel's shepherd.

At best, God's anointed kings desired to please, love, and obey him, but still failed.

At worst, they sought self-pleasure, self-love, and selfish ambition—the opposite of what God's king should be, the opposite of a good shepherd.

This is not the kind of leader Jesus is.

In John 9, the Son of God heals a blind man on the Sabbath and is accused (again) of breaking the law. The religious leaders simply can't see that Jesus is God—that he *wrote* the law—since they are spiritually blind to his glory. So when the now-seeing man points out their blind spots and confesses Jesus's deity, the religious elite coldly "cast him out" (John 9:34).

"The thief comes only to steal and kill and destroy," Jesus says in response. "I came that they may have life and have it abundantly. I am the good shepherd. The good shepherd lays down his life for the sheep" (John 10:10–11). As Jesus rehearses Israel's history, he confronts the religious leaders' long-held motivations in leading God's people. They are not after sacrifice, but selfish gain:

> "Thus says the LORD God: Ah, shepherds of Israel
> who have been feeding yourselves! Should not
> shepherds feed the sheep? . . . The weak you have
> not strengthened, the sick you have not healed,
> the injured you have not bound up, the strayed
> you have not brought back, the lost you have not
> sought, and with force and harshness you have
> ruled them." (Ezek. 34:2, 4)

But Jesus, the Good Shepherd, is the flesh-and-blood fulfillment
of God's promise:

> "I myself will be the shepherd of my sheep, and I
> myself will make them lie down, declares the Lord
> GOD. I will seek the lost, and I will bring back the
> strayed, and I will bind up the injured, and I will
> strengthen the weak, and the fat and the strong I will
> destroy. I will feed them in justice." (Ezek. 34:15–16)

Jesus is everything the former shepherds weren't. In every way
those leaders failed, he succeeded and continues to succeed:

Israel's shepherds were too busy looking out for number one.
Laser-focused on their own interests and needs, they missed the high
privilege of caring for the people God had entrusted to them, lost
sheep who were weak, sick, injured, and straying. But our Good
Shepherd made himself nothing, laying aside self, to serve the sheep
his Father had given to him (John 6:37; Phil. 2:6–7).

Israel's shepherds ruled with force and harshness, ignoring their
own sins and weaknesses and wielding their power at the expense
of the flock rather than for its benefit. But our Good Shepherd, who
knew no sin, "can deal gently with the ignorant and wayward, since
he himself is beset with weakness" (Heb. 5:2).

*Israel's shepherds couldn't ultimately make God's people safe
and secure.* But our Good Shepherd successfully seeks his sheep
and brings them back into safe pasture, where they can truly rest

and enjoy protection, purpose, joy, and peace forever (Ps. 23; John 10:27–28).

And he accomplishes all these things, not by power-plays, manipulation, and selfish demands, but by sacrifice, by the laying down of his very life.

. . . ━ . . .

God has made good on his promise. He is your Good Shepherd.

So how does he lead you as you lead your kids?

With loving authority shown through his unwavering commitment. No leader's commitment is more sure and trustworthy than your Good Shepherd's. You are his, and he is yours: "I give them eternal life, and they will never perish, and no one will snatch them out of my hand" (John 10:28). You have been bought at the cost of the Good Shepherd's life who became your sacrificial lamb. His blood makes good on his promise. And if he went that far, would he now leave you to figure out this motherhood thing on your own?

With loving authority shown through his kindhearted clarity. In leadership, clarity is kindness, and God has been so kind to speak clearly through his Word.[1] All of God's commands are for your good, and everything he says is true. "When he has brought out all his own, he goes before them, and the sheep follow him, for they know his voice" (John 10:4). When you hear and read his Word, your Good Shepherd is leading you along paths of righteousness (Ps. 23:3) that are best for you, that bring him praise, and that will equip you to shepherd your kids' hearts.[2]

With loving authority shown through his patient gentleness. Isaiah 40 tells us about the greatness of God's rule, which is unexpectedly gentle: "He will tend his flock like a shepherd; he will gather the lambs in his arms; he will carry them in his bosom, and

[1] More on this in chapter 9.

[2] God's Word may not tell us everything about everything, but it tells us all we need to know. This means his Word is *sufficient* for us.

gently lead those that are with young" (Isa. 40:11). Notice that last phrase, "with young": Jesus has a special, patient gentleness toward mothers. As your Messiah leads you, he does so with more patience than anyone else. You (and your kids) are wandering sheep; you need a good shepherd who will gently, patiently lead you back when you go astray, and when leading your children seems too much for you.

With loving authority shown through his promised presence. Astoundingly, Jesus shares with all his people the same intimacy he enjoys with his Father: "I know my own and my own know me, just as the Father knows me and I know the Father" (John 10:14–15). His deep affection for you fuels his attentiveness to you; he can't possibly leave you to yourself and your own resources. So he gives you his Spirit to guide, counsel, and help you as you raise your children. We'll look at the role of the Spirit in a future chapter,[3] but for now, be amazed that Jesus quite literally *gives you himself.* He takes up residence in your soul, promising always to assist you and never to abandon you.

· · · — · · ·

So, momma—when you don't know what schooling decision to make; when your son's special needs have you perplexed with no textbook answer; when you run out of strategies for your daughter's ill behavior at bedtime; as you wonder if anything you're teaching is clicking; as you bring your newborn home and have no clue what to do next; as you consider adding to your family through foster care or adoption; when you're making decisions about who your kids can play with, what they can watch and read, and how to best use the short years they are under your roof . . .

You could anxiously fret.

You could fear the future.

You could over-analyze your every decision.

[3] See chapter 11.

You could numb out with entertainment, food and drink, work, or social media.

You could strive with all your might to be a "great mom."

Or you could rest in the refuge of your Good Shepherd.

Actually, when Jesus is your Good Shepherd, you don't have a choice *but* to rest. "I myself will be the shepherd of my sheep, and I myself will *make them* lie down." In essence, he whispers, *Let me serve you. Let me lead you. Keep your eyes on me, and trust that my goodness and mercy will follow you.* He laid down his life so you could entrust him with yours.

No matter what decisions you have to make today, they're not too perplexing or too hard for him. He not only goes before you with the kindhearted clarity of his Word, he lives within you and is abundantly patient with you.

He is in this relationship for good.

He will shepherd you every step of the way, all the way home.

This is his heart: the anointed Shepherd-King of all, gently leading those with young.

BRING IT HOME

Meditate

Your Good Shepherd leads you with loving
authority: with the kindhearted clarity of
his Word, by the presence of his Spirit,
and with never-exhausted patience.

Reflect

Where do you see the motivations of
Israel's shepherds within yourself? What
difference does it make that your Good
Shepherd is the opposite of this?

PRAY

Good Shepherd,

Thank you for coming to earth not with power-plays and forcefulness, but in meekness and mercy. Thank you that you "gently lead those that are with young," that your eye is upon me as I shepherd my children. When the world's message of greatness resounds, reorient my mind and heart so I will firmly believe that to be truly great is to serve. Jesus, your heart-posture has always been one of humility; make my heart like yours. Lead me and guide me as I shepherd my kids. Amen.

PART 3

Humble unto Death

CHAPTER 7

He
Loves
You

Now before the Feast of the Passover,

when Jesus knew that his hour had

come to depart out of this world to the

Father, having loved his own who were

in the world, he loved them to the end.

JOHN 13:1

EXTRA READING: John 3:16–17; 10:17–18; 12:1–8; 13:1–35

They didn't expect this.

There in John 13, all eyes were on him as he stood up from the table, removed his robe, and donned a towel. After filling a basin with water, Jesus stooped and began untying sandals, the dust and filth of the day's travels flecking onto the floor. He submerged John's feet into the water and then followed with his own hands, plunging them into the expanding rings of dirt.

He dried the disciple's feet with a towel and moved on to the next man.

It was Peter's turn. His bewildered eyes were framed by flushed cheeks. "Lord, do you wash my feet?" he asked (v. 6).

Jesus smiled. "What I am doing you do not understand now, but afterward you will understand. . . . If I do not wash you, you have no share with me" (vv. 7–8).

To be estranged from his Lord would be the worst possible scenario, for Peter had grown to love him and would follow him no matter the cost. He exclaimed, "Lord, not my feet only but also my hands and my head!" (v. 9).

Minutes passed. Jesus continued his round, thoroughly washing every disciple, including the feet of his betrayer. No one spoke; no one knew what to say. The trickling of water was their background music, the sound of service filling the silence.

When he had finished, he sat down.

Speechless faces stared back at him.

"Do you understand what I have done to you?" Jesus asked. "You call me Teacher and Lord, and you are right, for so I am. If I then, your Lord and Teacher, have washed your feet, you also ought to wash one another's feet" (vv. 12–14).

· · · — · · ·

We have come to the end of Jesus's earthly ministry.

It is time for him to finish what he started, to serve all the way to the cross—

To humble himself unto death (Phil. 2:8).

John has given us glimpses of Jesus's future; we know the religious leaders are plotting to arrest and kill him.[1] But more striking, perhaps, is that Jesus already knows what they're up to, and he's not running away from it.[2] They believe they are thwarting his plan, but in reality they are fulfilling it: "No one takes [my life] from me, but I lay it down of my own accord. I have authority to lay it down, and I have authority to take it up again. This charge I have received from my Father" (John 10:18).

A brief encouragement for you, Mom: Your circumstances may feel like they're spinning out of control—a difficult child you can't seem to reach, sleepless nights and foggy days, a messy house that makes you feel chaotic inside, a course-altering diagnosis with an unknown future, a season of stressful changes, tension with your spouse, a pregnancy you weren't planning (or that you *were* planning and then you lost), an adoption that falls through, inexplicable waves of anxiety or postpartum depression—

But none of your circumstances exist outside of Jesus's loving authority.

When he is your Lord and Savior—your Bread of Life, your Living Water, and your Good Shepherd—you can trust that nothing comes to you apart from his goodness and perfect plan, even the trials that make motherhood a struggle. Sometimes our hardships are his grace in disguise, severe mercies straight from his loving heart to ours. A Savior willing to go to his death for your eternal sake is a Lord you can trust with everything else.[3]

Even when it makes no sense to you.

Even when it causes you to question his love.

His great, committed, unconditional love that does what is hard, a love that stoops low and lays itself down, is also a love that will never

[1] See John 7:32, 44; 8:59; 10:39; and 11:53.

[2] Jesus may have purposefully changed locations or stolen away from the crowds, but he did so because his time to die, as planned by his Father, had not yet come. He needed to stay alive until then.

[3] More on this in chapter 5.

abandon its beloved. His is a love you can count on, even when you least deserve it.

And this love is what John wants us to behold next.

• • • — • • •

> Now before the Feast of the Passover, when Jesus
> knew that his hour had come to depart out of this
> world to the Father, having loved his own who were
> in the world, he loved them to the end. (John 13:1)

What does it mean to love? What *is* love?

Love is often defined as a deep affection toward something or someone lovely.

Thanks to our imaginative three-year-old daughter, we act out a lot of scenes from princess stories in our home. Most of those stories speak of "love," but my husband and I are always trying to rewrite them because their idea of love is so shallow. The tales are almost always based on someone lovely, someone easy to love. But is this truly love?

We know that our marriage vows must be made on something more lasting than a temporary feeling because husbands and wives are not always lovely toward one another. And as mothers, we know how quickly a feeling of deep affection for our children can become a burst of anger or impatience toward them. They aren't lovable all the time, and neither are we.

What if love serves the unlovely and, in doing so, sees the unlovely transformed?

What if love takes initiative for another's benefit when they least deserve it?

What if love tells us primarily about the Lover rather than the beloved?

We don't have to wonder what love is, John tells us, because God is love (1 John 4:8), and he has acted for the good of unlovely people

at great cost to himself (Rom. 5:8). We'll see the workings-out of his great love in the next few chapters, the lengths he is willing to go to for his own. But here in chapter 13, John says that Jesus has always been the fullness of love, and it's how he always will be. That is a promise.

First, consider how Jesus has "loved his own who were in the world."

He willingly laid down his rights as God, took the form of a servant in human flesh, and entered the world he made. He became like those who had rejected him, and who would reject him again. He created us from love, and he came for love.

He called the disciples with his words, taught them with patience when they couldn't discern who he was, calmed their fears when circumstances seemed too much, and gave them the privilege of ministering in his name. He loved them in all their weaknesses.

He healed a blind man and an invalid, offering them a future on earth and capturing their hearts for eternity. He worked miracles to reveal what God has in store for those who love and follow him: a new world where all things are made right.

He welcomed a religious man and a Samaritan woman, among many others, offering to renew and satisfy them forever; and he forgave an adulterous woman, whom everyone was ready to stone for her offenses, with the merciful, life-giving words, "Neither do I condemn you; go, and from now on sin no more."[4]

Jesus has made God known (John 1:18): He made us and willingly came to us, he changes our hearts, he satisfies us, he provides for us, and he leads us. This is all from a heart that is "[truly] full of grace," that delights to serve his people—undeserving us—from his overflowing fullness, from a heart that is "gentle and lowly" (Matt. 11:29).

Who would've imagined that the God of all the universe is a God of humility?

[4] See the woman's story in John 7:53–8:11.

Who would've thought that his heart could be so set on loving people like us?

· · · ——— · · ·

Along with loving his own who were in the world, John says *he loved them to the end.*

Now Jesus prepares to go to his death and, beyond it, to assume his heavenly throne seated at the right hand of God. He's about to be in his Father's presence once again, enjoying the glory he had with him before everything existed (John 17:5), far from the darkness and sufferings and sin of this world—and once again, Jesus takes us by surprise.

The way to his crown is through a cross.

And so, the Son of God marks his way to Calvary, not with grandiosity but with a final act of service, a humble swan song.

He, the Lord of all, washes his disciples' dirty feet.

It's as if he's saying to them and to us, "If you have any doubts about my love for you, and about my intentions toward you once I'm in heaven again, let me leave you in no doubt."[5] He just won't let us miss the point of why he came: "For God so loved the world, that he gave his only Son, that whoever believes in him should not perish but have eternal life" (John 3:16).

The world. The dark, fallen world.

Jesus's love extends even into darkness and unloveliness.

It's easy to love someone who loves you back, but it's not so easy to love your enemy.

Yet Jesus did, enough to die in our place.

And not just to die, but to be utterly crushed by the fury of God's wrath against the collective sin of all his people. "This is love," John says, "not that we loved God, but that he loved us and sent his Son as an atoning sacrifice for our sins" (1 John 4:10 NIV).

[5] This is my paraphrase of Thomas Goodwin's incredible insight in *The Heart of Christ* (Edinburgh, UK: The Banner of Truth Trust, 2011), 9–11.

No—some filth on the disciples' feet cannot compare to the full force of God's wrath.[6]

Think about the dirt you're cleaning up every day. The diapers that need changing, the kids who need bathing, the shirts and pants that need laundering five minutes after they've come out of the dryer—a mother's work of washing and cleaning feels endless.

And as we've already confessed, it often feels *below us*.

The disciples' feet would've been as soiled as a baby's bottom, having absorbed the day's dirt from roads strewn with animal waste. Washing feet would've been considered a slave's job, below the dignity of most people, not to mention the Lord of the universe. Yet, "the Lord [serves] his servants."[7] Jesus doesn't shy away from dirty work—he moves toward it, demonstrating what he has come to do for our hearts. He once again takes the position of a servant, stooping and getting his hands dirty. He doesn't insist that he has done enough and loved enough and met his quota for good deeds, "and now it's finally time for me to get on with the glory I deserve." No—

He loved them to the end. And not just with hands plunged into dirty water.

He washes feet as a picture of how he'll wash hearts once-for-all: Through a body utterly plunged into the dark abyss of the grave.

$$\bullet \; \bullet \; \bullet \; \text{—} \; \bullet \; \bullet \; \bullet$$

As we behold how Jesus loves his people to the end, a love foretold in a foot washing and fulfilled on a wooden cross, we can't help but love him in return.

We can't help but be amazed, and worship.

[6] I appreciate Dane Ortlund's insights on this in *Gentle and Lowly: The Heart of Christ for Sinners and Sufferers* (Wheaton, IL: Crossway, 2020), 199–200.

[7] Goodwin, *The Heart of Christ*, 11.

Six days earlier, a woman named Mary had knelt before Jesus, anointing his feet with oil, kissing them and wiping them with her hair. She was face-to-feet with dirt and grime and had spent her expensive perfume on Jesus. She had not only served him, but sacrificed everything for him.

In humble worship, she washed the feet of the One who had first washed her heart.

Without knowing it, she had obeyed the command Jesus would give his disciples after he had washed them: "If I then, your Lord and Teacher, have washed your feet, you also ought to wash one another's feet. . . . A new commandment I give to you, that you love one another: just as I have loved you, you also are to love one another" (John 13:14, 34).

Motherhood is hard work. It is demanding, full of toil, and often dirty work. Despite our best intentions, a mother's love has an endpoint—but Jesus's love knows no end. When we realize that our greatest problem isn't the tantrums and conflicts and tiredness and messes and dirt and grime before us, but the lack of love in our hearts and in our kids' hearts, our response to Jesus's great, unending, cleansing love becomes like Mary's—"Yes, Lord; I believe that you are the Christ" (John 11:27)—and like Peter's—"Lord, not my feet only but also my hands and my head!" (John 13:9).

Cleanse us, Lord! We need you! Humble our hearts with your love!

As you wash unlovely, dirty little feet with your hands, may your heart cling to his love that always supplies what you lack. When you stoop, may you do so as a picture of his high, wide, long, and deep love for you. May the song of your motherhood be service for him, as you love him with your hands from the worship flowing from your heart. And in that, may you love your kids in the truest way, to the very end, as a reflection of his inexhaustible love for you.

"You are serving the Lord Christ" (Col. 3:24).

A Savior
willing to go to
his death for your
eternal sake is a Lord you
can trust with everything else.
His great, committed,
unconditional love that
does what is hard,
a love that stoops low and
lays itself down, is also a love
that will never abandon
its beloved.

His is a love
you can count on,
even when you least deserve it.

BRING IT HOME

Meditate

Jesus's heart is set on loving you to the very end, and as his great love moves you to humble dependence and worship, it will overflow in service to your children.

Reflect

What are some demanding parts of motherhood that make it hard to stoop to serve your kids? When do you find your love exhausted? How does Jesus's promise, example, and command in John 13 encourage you?

PRAY

Cleanse me, Lord! I need you!

Humble my heart with your love. Thank you, Jesus, for loving me while I was yet unlovely, and for promising to love me to the end. The stores of my love toward my children are limited and easily exhausted; fill me with your great, deep, inexhaustible love. Fill me with the love that you command me to have toward my kids, even when it costs me and means stooping low like you did. Help me love them as you have first loved me. In your precious name, amen.

He
Takes
Your
Place

So Jesus said to Peter, "Put your sword

into its sheath; shall I not drink the

cup that the Father has given me?"

JOHN 18:11

EXTRA READING: John 18–19

You know the moment.

The moment you thought you'd never see because you'd *never* do such a thing.

The moment you get angry—I mean *really* angry—and say things and act toward your child like you promised you never would.

Before you can anticipate or stop it, the moment happens—like a cloud burst, it happens—and you stand before your child appalled.

Not at them, but at yourself.

You had no idea you were capable of such a thing.

Where do you go from here?

The guilt is palpable, turning your stomach and weighing down your conscience. What's done is done; you can't turn back the clock and erase what happened. You failed. Big time.

And you wonder what God thinks about you now.

When we lash out, say things we don't really mean, and match our kids' emotions with toddler-level maturity; when we sin against our kids and against the Lord, and when our children sin against us; when our guilt announces our condemnation, we are desperate for good news—good news that deals with the heart of the problem: Jesus humbled himself to the point of death to put away all our sin.

· · · ━ · · ·

This isn't only good news—it is startling news.

As we come to the crucifixion, it would be easy for us to rush past it, finding it familiar and generally comforting. *Yes, yes, Jesus loves me, this I know. He died for my sins. I am forgiven.*

But we don't want to do this. Instead we want to linger over what happened there. Just as *every* mom will savor an expensive meal rather than scarfing it down (which is what we're usually doing at dinnertime), so we want to revel in the costly humility of Jesus. We want our souls surprised and stirred by his sacrificial love, a love willing to suffer and die for the unlovely. And we want this to make a difference in our motherhood.

So take this in again:

Jesus humbled himself to the point of death to put away all your sin.

In other words, *Jesus frees you, Mom, from attempting to be your own Savior, and he frees you from the impossible task of saving your children.*

Take a deep breath. This is terrific news.

Up to this point, we have explored several ways mothers are privileged to imitate and reflect Jesus to our kids. We care for them, shepherd them, provide for them, and stoop to serve them. But now we have arrived at a crossroads—or shall I say, a cross—where we behold the Son of God serving us in a matchless way, in a work we'll never be able to imitate or execute in motherhood.

He humbles himself to take our place under God's wrath, becoming the perfect sacrifice for undeserving, yet wholly beloved sinners. For you and for me.

. . . — . . .

The direction of John's Gospel has shifted. Jesus is headed to the cross.

The cross is the event all others have anticipated, that Jesus has been moving toward and talking about. The Son of God came to die: "Now is my soul troubled. And what shall I say? 'Father, save me from this hour'? But for this purpose I have come to this hour" (John 12:27).

For what purpose? *To remedy the problem of sin*—the pervasive shadow looming over our world that lives in each of our hearts—and free his people forever from its grip.

Jesus spoke some choice words about this problem: "I told you that *you would die in your sins*, for unless you believe that I am he *you will die in your sins*. . . . Truly, truly, I say to you, everyone who practices sin is *a slave to sin*" (John 8:24, 34, italics added).

That's some powerful language. We cannot lighten it up or ignore it.

To be enslaved to something is to be ruled and oppressed by it. Sin, then, isn't just some bad stuff we sometimes do in response to annoying people or complex situations (like we discovered in chapter 2). Rather, it is a *driving compulsion* within us to want our own way and reject God's way, to seek our own interests and serve ourselves instead of seeking God's interests and serving him (or others). Before Christ takes the throne of our hearts as our anointed Shepherd-King, sin actually controls us like a severe master, leading us into evil and determining what we love: "people loved the darkness rather than the light because their works were evil" (John 3:19).

This means, Mom, that your greatest problem isn't outside of you, but within you.

It isn't that your son refused to take his nap today, or that your daughter had multiple tantrums today, or that your vacation got cancelled because everyone got sick, or even that the pain in your lower back won't seem to let up. This isn't to say that these *aren't* problems; they are, and we should address them if we can. Even Jesus healed and helped people with their sufferings and maladies.

But his words above put all our problems in perspective:

Sin will always be our biggest issue.

Yes, Jesus healed people, and he did so not only out of compassion for their temporary ills, but to paint a picture of the bigger work he was up to: healing their hearts. *Heart change.* That's what he is after, first and foremost.[1]

Unless Jesus reigns on the throne of our hearts as our anointed Shepherd-King, changing us to worship and serve him, our sin means we remain his enemy. And what God's enemy receives is his holy opposition. "The wrath of God remains on him" (John 3:36).

Unless, of course, God himself intervenes.

And he does. In his Son.

[1] For example, see Matthew 9:1–6; Mark 10:46–52; and John 5:1–17.

> Jesus answered them, "Truly, truly, I say to you, everyone who practices sin is a slave to sin. The slave does not remain in the house forever; the son remains forever. So if the Son sets you free, you will be free indeed." (John 8:34–36)

Sister, if you have seen and owned your sin for the problem it is and trusted Christ to rescue you from it, you are no longer under its enslaving rule. You are free. Sin may still be your biggest problem, but not because it has ultimate mastery or authority over you. God is now your Father, and you are his child. *In Christ, you no longer serve sin. You now serve him.* "Thanks be to God, that you who were once slaves of sin have become obedient from the heart" (Rom. 6:17).

This means two other important things: One, our kids are up against a sin-problem only Jesus can solve. And two, our hearts are at war.

We are no longer under sin's power, but we remain in its presence. It is still a problem.

We are free from our slave-owner, but he still haunts and tempts us.

And sometimes we listen. Sometimes we give in.

Sometimes the cloud-burst moment happens, and we do the things we don't want to do.

When this happens—and it happens to the best of us—we have a choice. We can either melt down in guilt and shame, avoiding God (as if we could) for fear of his disapproving gaze. Or, with all our burdens, we can run straight to him, into arms that were once spread wide on a cross to bear precisely *this* guilt and *this* shame.

With all the limits of our love, if we receive our children like this when they come humble and repentant to us, how much more will our loving Father receive us?

· · · — · · ·

But how can this be, we wonder, when our sin is such a massive problem?

Because Jesus drank the cup of God's wrath, the full and complete outpouring of his righteous anger against sin.

"Shall I not drink the cup that the Father has given me?" (John 18:11).

God's wrath is a hard reality to swallow because sin is much too easy for us to swallow. As we're often teaching our kids, a small problem warrants a small consequence, but a *big* problem warrants a *big* consequence.

If we truly felt the weight of sin, we wouldn't be so surprised by God's response to it.

Yet, once again, the *way* God responds to it isn't what we would expect.

We tend to think that God is like us in our angry emotional outbursts, when we get irritated with our kids and blow up at them. Yet God describes himself as "merciful and gracious, slow to anger, and abounding in steadfast love and faithfulness" (Exod. 34:6). Contrary to our suspicions, he is incredibly patient with us and full of mercy. When Jesus says he must drink the cup of God's wrath, he is saying that God's righteous, measured response to every sin, stored up across the centuries in his patience, must finally be poured out, spent, satisfied—and that he, not us, will drink it.

He will take our place. He will drink the cup.

> For while we were still weak, at the right time Christ died for the ungodly. For one will scarcely die for a righteous person—though perhaps for a good person one would dare even to die—but God shows his love for us in that *while we were still sinners, Christ died for us*. Since, therefore, we have now been justified by his blood, much more shall we be saved by him from the wrath of God. (Rom. 5:6–9, italics added)

Jesus frees you, Mom, from attempting to be your own Savior, and he frees you from the impossible task of saving your children.

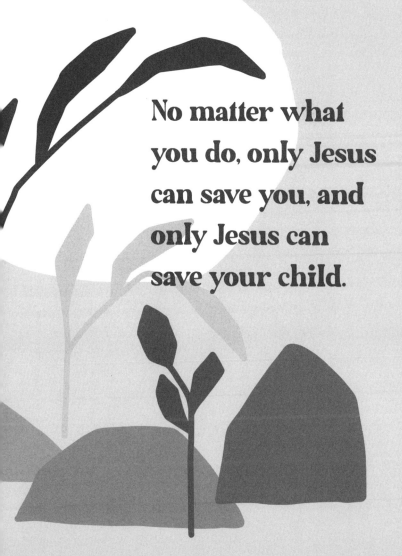

No matter what you do, only Jesus can save you, and only Jesus can save your child.

Just as perfect divine love overflowed to create the world and everything in it, so perfect divine love planned from eternity-past to remedy the human problem of sin. Father and Son, one in heart and mind, in the bond of the Spirit's fellowship, linked their proverbial arms in a saving mission to spare the children of wrath—you and me—from the punishment our sin deserves.

The Father set his love upon a people, and his Son therefore set his face to a cross.

As John Stott would put it, "Divine love triumphed over divine wrath by divine self-sacrifice."[2]

We cannot fathom what Jesus experienced—body, mind, and soul—on the cross. There, he would drink the full cup of God's wrath, poured out in response to the ugliness of every believer's sin that had been mercifully passed over throughout the ages (Rom. 3:25). Dane Ortlund wonders, "What must it have been for the sum total of righteous divine wrath generated not just by one man's sin but 'the iniquity of us all' to come crashing down on a single soul?"[3]

It is unfathomable. Unbearable, if we try to fathom it.

But Jesus bore it all, sacrificing himself by taking our place.

· · · — · · ·

What does this mean for you, Mom?

No matter what you do, when you belong to Jesus, your place in God's family is secure. Your standing as an adopted child of God depends entirely upon the finished work of Christ, the perfect Son. In every way that you have failed to love and serve your Father (and your kids), he has fully and finally succeeded: "[Jesus] said, 'It is finished,' and he bowed his head and gave up his spirit" (John 19:30).

[2] John Stott, *The Cross of Christ* (Downers Grove, IL: InterVarsity Press, 1986, 2006), 158.

[3] Dane Ortlund, *Gentle and Lowly: The Heart of Christ for Sinners and Sufferers* (Wheaton, IL: Crossway, 2020), 200.

So, when the cloudburst moment happens and sinful anger gets the best of you—when you wonder what God thinks about you now, and you're tempted to listen to condemnation's voice, sinking under guilt and shame—envision Jesus bearing *that sin* in his body on the tree, and rejoice that *he's already taken the punishment you deserve for it*, securing your complete forgiveness, freedom from sin's enslaving rule, and an irremovable place in God's family.

If he loved you like that while you were his *enemy*, will he not love you now that you are God's adopted child? Will Jesus not delight in receiving you, in all your guilt and grief, to sing over you his indestructible love as proven for you on the cross?

Jesus's sacrifice also means that *no matter what you do, only Jesus can save you, and only Jesus can save your child*. Motherhood means sacrifice—your last bites of ice cream, your pre-baby body, those eight-straight hours of glorious nighttime sleep, your financial freedom, the clean car, the clean house, the clean shirt. All sacrificed on the altar of motherhood. In many symbolic ways, we are laying down our lives for our kids, and if it came to it, we know we would die for them.

But we can't save them from sin.

We can try to spare them from a lot of things—emotional hurt, physical pain, and other forms of hardship—but we will never be able to sacrifice enough to remedy their biggest problem. And we will never be able to sacrifice enough to solve ours; no depth of guilt over our sins and failings and no amount of striving to be good enough will do.

Only Jesus's costly self-sacrifice is enough to save them and us.

Only his sin-destroying, penalty-removing, mercy-releasing sacrifice will do.

What a relief.

What an invitation to repent and rejoice in the finished work of your servant Savior.

And what an invitation to serve him another day since he didn't stay dead, but rose triumphant from the grave.

BRING IT HOME

Meditate

Jesus humbled himself to death and drank the cup of God's wrath in your place, freeing you from trying to be your own Savior and from the impossible task of saving your children.

Reflect

The next time you lose your temper or sin against one of your children in another way, what would it look like for you to depend on Christ's sacrifice? How would confession, repentance, forgiveness, and rejoicing help you move forward in hope?

PRAY

Loving Father,

It is astoundingly good news that you set your love on unlovely sinners and gave us your Son. Thank you for sparing me from what my sin deserves! Thank you for not sparing your Son so that I can be forgiven and freed from sin's grip. Help me clearly see where I'm trying to save my kids (or myself) so I can repent of attempting to be a savior. Convince me of Jesus's sufficient sacrifice, that he paid for every sin and humbly served me all the way to his death, so I can now walk in joy, peace, and freedom as I daily lay down my life for my kids. In his name, amen.

He Reveals Himself to You

Thomas answered him, "My Lord and my God!" Jesus said to him, "Have you believed because you have seen me? Blessed are those who have not seen and yet have believed."

JOHN 20:28–29

EXTRA READING: John 15:1–17; 20; 21:1–14

It's hard to imagine what Jesus's loved ones must have felt that day at Calvary.

Their hopes for a Messiah, shattered. A dearly beloved friend, dead and gone.

After Jesus took his last breath on the cross, his body was wrapped in linens and placed in a tomb. Our friend Nicodemus laid him there (and John gives us reason to believe the Pharisee had truly been born again). A heavy stone was rolled in front of the tomb's entrance to prevent anyone from stealing the body. And night fell.

For two days, nothing happened. All was quiet and still—

Until the Spirit came. And with the Spirit came life and power and hope.

Lungs expanding with the breath of God, Jesus would've opened his eyes entirely new.

And a once-dead man would've walked straight out of his grave.

• • • ━ • • •

Consider the last time you felt discouraged.

I'm guessing it hasn't been long. Most moms on most days are stretched to the max and burdened beyond our strength. Our little people have so many needs, and there's so much housework to do, and our other job is calling for us, and then there's the complicated matter of our kids' hearts (plus our own), and, and, and . . .

When our children's demands feel endless and we can't seem to meet them; when we are overwhelmed by our to-do list and can't keep up; when our kids disappoint us and we disappoint ourselves; when we are tempted to sadness, discouragement, or despair—we need a resurrection reality check.

We need our faith in Christ strengthened and our eyes lifted.

We need to remember that *Jesus walked out of his grave.*

When we talk about the resurrection, we're often referring to a future reality. But that's not the only way it applies. Yes, it's true that one day Jesus will come again on the bright clouds with glory,

taking all his people home to heaven-on-earth where we will enjoy him forever in new and resurrected bodies. (Come, Lord Jesus!)[1] But through his resurrection, Jesus beckons us into a present reality that gloriously affects our minds and hearts and motherhood right now.

In John Owen's words: "He loves life into us."[2]

That's where we're headed in the next three chapters.

. . . —— . . .

Mary Magdalene was one of the first people to see the risen Christ.

We're told in Luke 8:2 that Jesus had cast out seven demons from her, and that she was one of "some women" who had followed him during his ministry. She knew Jesus, she heard him speak, and she loved him. Mary also witnessed the crucifixion, standing by the cross alongside Jesus's mother (John 19:25), and would've seen him suffer in agony and eventually die.[3]

So when Mary finds the stone rolled away from Jesus's tomb, naturally she is distraught over her friend's missing body. Three times she says, "They have taken the Lord out of the tomb, and we do not know where they have laid him" (John 20:2, 13, 15). In her confusion, panic, and sadness, she breaks down weeping. Then,

> . . . she turned around and saw Jesus standing, but
> she did not know that it was Jesus. Jesus said to
> her, "Woman, why are you weeping? Whom are
> you seeking?" Supposing him to be the gardener,
> she said to him, "Sir, if you have carried him away,

[1] We will focus more on this in the last chapter.

[2] John Owen, *On Communion with God, in The Works of John Owen*, ed. W. H. Goold (repr., Edinburgh, UK: Banner of Truth Trust, 1965), 2:63, as quoted in Ortlund's *Gentle and Lowly*.

[3] Jesus's valuing of women would've been counter-cultural and should be such an encouragement to us. In these times women and children were considered less-than, yet the risen Jesus first revealed himself to women! Consider also how Jesus particularly valued and loved his mother while he was dying on the cross, entrusting her into John's care (see John 19:25–27): "Woman, behold your son!"

> tell me where you have laid him, and I will take him
> away." Jesus said to her, "Mary." She turned and
> said to him in Aramaic, "Rabboni!" (which means
> Teacher). . . . Mary Magdalene went and announced
> to the disciples, "I have seen the Lord"—and *that*
> *he had said these things to her.* (John 20:14–16,
> 18, italics added)

What was it that caused Mary to recognize Jesus? *He spoke to her.*

And what brought Mary from despair to hope? *She had seen the Lord.*

As moms, we are no strangers to sadness. We know what it's like to cry tears of discouragement after an extra-long day, as we wonder if we're making any difference. We know what it is to weep over our children whether they're needy newborns, emotional toddlers, defiant kids, or prodigal teens. We also know the sometimes-inexplicable tears of overtiredness and fluctuating hormones, and perhaps even the darkness of postpartum depression.

Every mom knows what it is to weep, and to feel like Jesus is far away.

But God gives us Mary's story to encourage us:

The risen Jesus revealed himself to her by speaking to her.

And in revealing himself, he strengthened her faith and gave her hope.

· · · — · · ·

The same evening, Jesus appeared to a roomful of his disciples, but Thomas wasn't with them. So when they told Thomas, "We have seen the Lord," he said to them, "Unless I see in his hands the mark of the nails, and place my finger into the mark of the nails, and place my hand into his side, I will never believe" (John 20:25).

Talk about honest! It's easy for us to wonder why Thomas wouldn't trust the collective witness of the disciples. (What's *wrong* with him?)

But what Thomas had seen happen to Jesus was the epitome of sad and discouraging. Why should he believe that a dead man had come back to life?

Jesus's approach to Thomas isn't what we would expect. Rather than rebuking Thomas (or any of the disciples who had abandoned him, for that matter), and rather than refusing to come to him because Thomas "should just have more faith," Jesus patiently reveals himself to him. The risen Lord once again humbles himself, meeting his disciple right where he is:

> Then he said to Thomas, "Put your finger here, and see my hands; and put out your hand, and place it in my side. Do not disbelieve, but believe." Thomas answered him, "My Lord and my God!" Jesus said to him, "Have you believed because you have seen me? Blessed are those who have not seen and yet have believed." (John 20:27–29)

What Jesus says to Thomas is a balm to a weary mother's heart: *Blessed are those who have not seen and yet have believed.*

• • • —— • • •

We have not seen Jesus with our eyes. We didn't follow him during his ministry like Mary, or have our feet washed by him like Thomas. Yet Jesus says we don't need to physically see him in order to trust him and love him.

So what does believing Jesus look like for us today? What does it look like to depend on him when we're tired with discouragement, when motherhood gives us many reasons to weep and doubt?

John tells us: "Now Jesus did many other signs in the presence of the disciples, which are not written in this book, but these are written so that you may believe that Jesus is the Christ, the Son of God, and that by believing you may have life in his name" (John 20:30–31).

These are written. Jesus gives us his Word. The Bible on your nightstand or coffee table or bookshelf is no ordinary book, but a precious gift from him. We grow in trusting him as he reveals himself to us there, speaking straight to our hearts about who he is and all he has accomplished to serve and love his people into resurrection life. His speaking to us does at least three things: strengthens our faith, increases our joy, and makes our hearts like his.

Jesus gives you his Word to strengthen your faith in him. John Piper says, "Whatever brings saving faith into being and sustains it and strengthens it is to be pursued with all our heart."[4] And God's Word does precisely this. In your doubts, do you need to remember the truth of who God is today? In your discouragements—in all the trials that make motherhood hard, that make you forget how loved you are, that bring you to suspect God of holding out on you—do you need to remember all the ways Jesus has served you?

In the mad rush of motherhood, it's easy to let our Bibles collect dust on the shelf. Perhaps this is because we haven't yet been convinced of the life-giving, faith-strengthening nature of God's Word. As bread sustains our bodies, so his words sustain our souls (Deut. 8:3; Matt. 4:4). We need Scripture so our faith does not wither, so we do not remake God in our own image, and so we become mothers who can discern truth from error.

Maybe the thought of reading the Bible overwhelms you in this exhausting season. Start small. Read a few verses, or one chapter at a time (like you've done throughout this book). Leverage the margins of your day to meet with God in his Word; there are many, and they add up! Read while nursing, during naptime, while waiting in the car line at school, or with your kids over breakfast. Or listen to it on speakerphone as you're getting ready in the morning, letting it speak

[4] John Piper, *Reading the Bible Supernaturally: Seeing and Savoring the Glory of God in Scripture* (Wheaton, IL: Crossway, 2017), 124. This is one of my all-time favorite books, and I *highly* recommend it to you. It has influenced the way I think about, approach, and engage with God in Scripture.

over your soul and your day.[5] Or perhaps join a women's or mother's Bible study or small group at your church.

You don't necessarily need to wake up at the crack of dawn to meet with Jesus. There are no rules here, only priorities and a great promise: "So faith comes from hearing, and hearing through the word of Christ" (Rom. 10:17).

Thank the Lord he has given us an unchanging, enduring Word to flee to that will tell us exactly who God is and who we are. It is to be pursued with all our hearts.

Why? Not just to increase our faith, but for our joy.

· · · —— · · ·

Jesus gives you his Word to increase your joy in him. Jesus once spoke to his disciples about staying close to him, promising them that the effect of this abiding is joy. "These things I have spoken to you, that my joy may be in you, and that your joy may be full" (John 15:11).

My joy. What exactly is Jesus's joy like? Remember the perfect, infinite love shared between Father, Son, and Spirit? Their love overflowed to create the world and everything in it.

And *their joy* is the joy Jesus is talking about:

Unconditional, indestructible, unending relational happiness.

Sweet fellowship, perfect companionship, and satisfaction in God.

Yes, Lord, I would like that kind of joy!

And this is precisely what he offers us in giving us himself through his Word. I can't put it any better than John Piper does:

> The divine aim of Scripture is not that by reading we be *moderately* joyful. The aim is that our joy— the joy of Christ in us—be *full*. Full would mean, at least, so strong that it pushes any idolatrous

competing pleasures out of our heart. It would mean that selfishness has come to an end. We are no longer to be a sinkhole of craven neediness, but a fountain of life—givers, not takers . . . who can tell what measures of joy in God are possible . . . if we give ourselves utterly to the word of God?[6]

Joy in the risen Jesus is what weary moms need above all else.

So he beckons us to pursue him and enjoy him—by opening our Bibles.

After a tough morning with our kids, when they're finally down for their naps and we sink into the couch exhausted, a piece of dark chocolate may help for a brief moment, but what we're *desperate* for—what our souls truly long for and need most—is life-giving, lasting, unshakable *joy* in a risen Savior who walked out of his grave. We need eternal, living *hope*, a reality check that lifts our eyes and hearts off our circumstances to the unseen kingdom of Christ, our good and gracious Shepherd-King, who is alive, and is with us by his Spirit, and is working out all his purposes—even the hard ones in our homes—for his own honor and for our Christlikeness, our joy, our humility.

Jesus gives you his Word to make your heart like his.

So, we push back despair and discouragement and sadness. Rather than retreating into our own dark thoughts or the incessant messages of a million people on social media, we turn to our Bibles. We "open the vent of [our] heart to the love of Christ"[7] because faith comes from hearing, and hearing through his Word.

The Bible is not like any other book. It is *alive* because its Author is risen.

It is a fount of truth to drink from (Isa. 55:1–3). It is the sword of the Spirit to fight with (Eph. 6:17). It is a living seed that bears eternal fruit (Luke 8:11; 1 Pet. 1:23).

[6] Ibid., 123.
[7] Ortlund, *Gentle and Lowly*, 188.

And the more we steep our hearts in it, the more our hearts begin to absorb his heart; and by the help and power of his Spirit—the same Spirit that raised Jesus from the dead—we are changed. We are brought from death to life.

Even when we can't discern it, God's Word is doing his work.

And our affections, perspective, motives, and actions increasingly look like his.

We trust and love and obey, more and more, the One who has first loved us.

And little by little, day by day, our hands and hearts more joyfully become *one* in this thing called motherhood. Because faith in a risen and reigning Shepherd-King changes us.

· · · — · · ·

Are you discouraged today, Mom? Do you need to fight sadness, doubt, even despair?

To whom shall you go? He has the words of eternal life (John 6:68).

Jesus walked out of his grave.

So run to the living Word of the living Christ.

BRING IT HOME

Meditate

The risen Jesus gives you his precious Word, revealing himself to you in order to strengthen your faith in him, increase your joy in him, and make your heart like his.

Reflect

When you're sad and discouraged, where do you tend to go? What would it look like for you to pursue joy in Jesus by increasingly giving yourself to his Word?

PRAY

Almighty God,

Thank you for giving me the Gospel of John, and the whole of Scripture, so that I would believe in and enjoy Jesus. Please God, help me prioritize your Word. May my heart seek you, and make my heart like yours. I need your Spirit to be at work through your words, strengthening my faith and making me more like you. Even as I encounter the hardships and disappointments of motherhood, give me joy in encountering Jesus through my Bible. In his name, amen.

PART 4

Humble in Heaven

He
Prays
for You

"I am praying for them. I am not praying for the world but for those whom you have given me, for they are yours. All mine are yours, and yours are mine, and I am glorified in them."

JOHN 17:9–10

EXTRA READING: John 17:1–26

Have you ever wondered what Jesus is doing right now?

So far this whole book has been about what Jesus *has done*, which is a wonderful thing. There is no salvation, no new heart, no freedom from sin, no treasuring of Christ, and no humble motherhood apart from Jesus's incarnation, life, death, and resurrection.

But there is more. There is good news within the good news, another remarkable aspect of our humble Savior's work to depend on and enjoy as we seek to serve our kids:

The risen Lord Jesus is serving us right this very moment in heaven.[1]

Even though he has sat down at the Father's right hand in glory— he continues giving himself to us because his heart is that humble.

· · · —— · · ·

After John records the resurrection appearances of Christ, his Gospel ends. He doesn't tell us when or how Jesus ascended into heaven, but we know it happened. Mark's Gospel says, "So then the Lord Jesus, after he had spoken to them, was taken up into heaven and sat down at the right hand of God" (Mark 16:19). John may not wrap up his story like this, but his contribution to Jesus's ascension is unique: he is the only writer, inspired by God's Spirit, who gives us access into Jesus's heart and mind as the Son unveils what will happen after he ascends to his Father.

So let's back up several chapters to the Upper Room (John 14–17) where Jesus has just washed his disciples' feet. Now he begins to speak to them.

Just as a tenderhearted mother knows to prepare her child's little heart for change, Jesus prepares his disciples for his departure. (If our kids struggle when we leave, how much more the men who had so closely followed the Light of the world and grown to love him?) Then he prays for them and for us.

[1] See Romans 8:34; Philippians 2:9; and Hebrews 1:3–4; 4:14–16; 7:23–28.

In his sermon and prayer Jesus bares his heart, telling us why he hastens to his heavenly home and what he will do there.

He is eager to send his Holy Spirit (who we'll look at in the next chapter).

And he is eager to intercede for his people.

・・・ —— ・・・

What does *intercede* mean?

Hebrews 7:25 tells us that Jesus "always lives to make intercession" for those who draw near to God through him. The word *intercede* means "to intervene on behalf of another"[2] or in John Bunyan's words, "prayer that is made by a third person, about the concerns that are between two."[3] So Jesus's intercession means he is always praying for his people before his Father in heaven.

We may wonder why he is doing this. After all, isn't his work "finished"? Jesus has set us free from sin and made us children of God, and now we have access to our Father through his peace-making blood (Heb. 10:19–20). In Christ, we are forgiven, accepted, and adopted as daughters. Yet, Jesus continues to intervene on our behalf.

Why?

Because he is committed to seeing us all the way home.

It is his delight to intercede "because the Son's heart is so full toward us,"[4] and he refuses to leave us to our own strength and devices. If he did, we wouldn't make it. There are too many temptations from without, too many snares from within, too many heart-obstacles to trip us up and evil maneuvers to bring us down.

No, Jesus must have *every single one* of his people with him in heaven. Not one of his sheep will be lost (John 10:28–30). That's a promise, and that is his aim: "Father, I desire that they also, whom

[2] Google Dictionary, "Intercede," as searched on March 31, 2021.

[3] John Bunyan, *The Intercession of Christ: Christ, a Complete Savior* (Fearn, Ross-shire, Scotland: Christian Focus Publications), 18.

[4] Dane Ortlund, *Gentle and Lowly: The Heart of Christ for Sinners and Sufferers* (Wheaton, IL: Crossway, 2020), 80.

you have given me, may be with me where I am, to see my glory that you have given me because you loved me before the foundation of the world" (John 17:24).

You may have many good goals, mom: weaning your baby, helping your toddler walk or talk, potty training, prepping for preschool, sleeping through the night.

But what is Jesus's goal for you? *That you will be with him and see his glory.*

Eternal joy in his glorious presence is what he wants most for you.[5]

He is committed to accomplishing this goal, as committed as he was when he took your place on the cross. And the way he accomplishes it? He never ceases to pray for you.

Take this in, Mom: *Jesus is praying for you right now.*

It always encourages me to know a friend is praying for me; how much more the Son of God? This reality brings strength. Strength to take the next step and do the next thing for your kids or your marriage or your church or yourself; strength to fight temptation and resist sin; strength to deny yourself one more time, to rest when work keeps bidding you come and worship at the altar of email, to work when laziness bids you just as strongly, to change one more diaper or give one more feeding or forgive one more offense; strength to humbly serve your kids another moment and another day, even when it's hard.

Doesn't Jesus's unwavering commitment to you *right now* make you want to press on?

By his intercession, you will. He will carry you. And not just sometimes, not just part of the way, but always and all the way home.

· · · — · · ·

"You've got this" is a popular encouragement for moms. But what's behind it?

[5] We'll look into this awesome future more in chapter 12.

Jesus's intercession means he is always praying for his people before his Father in heaven.

He refuses to leave us to our own strength and devices.

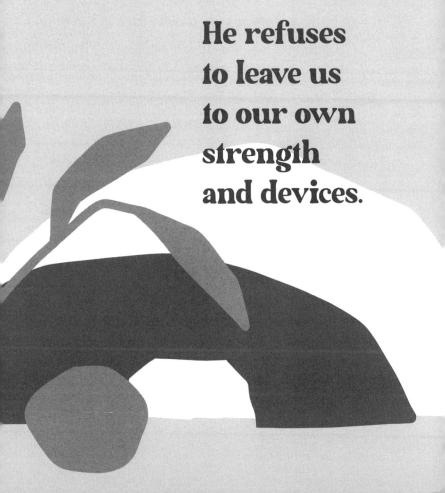

If it's a belief that I naturally have what it takes (*hair toss*) to keep my children alive, help them flourish, and even see them come to Christ without completely losing my mind in the process—then I definitely don't "got this." Not on my own.

Most days, I'm painfully aware of my insufficiency.

Yet, how often do we mother from our own strength and resolve? In other words, how often do we forget that Jesus's service to us extends far beyond our initial conversion? In Dane Ortlund's words, "He does not forgive us through his work on the cross and then hope we make it the rest of the way."[6] No, Jesus is committed to achieving his heavenly goal for us, carrying us all the way home.

The most dangerous position you can be in is to think you've "got this," Mom.

But if you know that you don't "got this," you're in the best place you can be. Why? Because Jesus humbles himself to serve the humble-hearted. His help abounds for those who know they need it.

This means that the most opportune, blessed position you can be in today is dependence on the Son of God, your elder brother, as he intercedes for you before his Father and your Father.

And what exactly is he praying for you?

Let's look at John 17 for at least three answers to this question.

· · · ━ · · ·

"I do not ask that you take them out of the world, but that you keep them from the evil one" (John 17:15). In this first prayer, Jesus is praying for your protection from evil. When he says "the world," he means our present reality, an earthly kingdom still under shadow of darkness because it rejects God's Son (John 1:10) and loves what is evil (John 3:19). Then there's the ruler of this world, the devil (John 12:31), whose sole objective is to keep people in darkness and misery. Finally, there's the remaining evil of our own

[6] Ortlund, *Gentle and Lowly*, 84.

hearts that tempts us to sin. Even though Jesus has set us free from sin's power and penalty, its presence lingers until the day we see his face.

The world, the devil, and our flesh are a strong combination, strong enough to derail anyone from reaching the glory of eternal, resurrected life—but *Jesus is stronger*.

He defeats the darkness and overcomes the world (Col. 2:15; John 16:33).

He destroys the works of the devil (1 John 3:8).

He sets enslaved sinners free and gives his Spirit so that we have power against the flesh (John 8:36; Gal. 5:16).

And so, he prays for your protection from evil.

This means at least two things for you, Mom. *One, in Jesus Christ you have the ability to say no to sin.* "For sin will have no dominion over you, since you are not under law but under grace" (Rom. 6:14). Remember: *you are not who you once were.* You belong to Jesus now, and you serve him, not sin. So, as you stay close to Jesus through his Word, and as his Spirit works in you a desire to please and obey him, you will increasingly love what he loves and hate what he hates.

As you consider who you are in Christ, he will strengthen you to *be who you are*, to "[abide] in him" and "walk in the same way in which he walked" (1 John 2:6). This will make all the difference when your kid is driving you nuts, and you can feel your blood boiling, and you're on the brink of that cloudburst moment. *Jesus is praying that you will say no to sin—that you will be who you already are in him.* Through his intercession, you can. And by his Spirit, you will.

Two, in Jesus Christ you have an advocate when you sin. Even if we have the *ability* to say no to sin, sometimes we don't have the *desire* to say no. Our spirit indeed is willing, but our flesh is weak (Matt. 26:41). Then the cloudburst moment happens. What then? "If anyone does sin, we have an advocate with the Father, Jesus Christ the righteous" (1 John 2:1).

Jesus's advocacy is one aspect of his intercession. Before the Father, he pleads his forgiving, cleansing blood over all his peoples' particular sins. And not a kind of begrudging, ashamed, "I-can't-believe-she-did-it-again" pleading, but a sympathetic, tenderhearted, "I-will-not-abandon-her" pleading. *If remedying our sin-problem is why Jesus came to earth, then would our remaining sin-problem repulse him in heaven?* No. "When you sin, his strength of resolve rises all the higher. . . . He cannot bear to leave us alone to fend for ourselves."[7]

So the next time you sin, don't bear it alone. You have an advocate, and his name is Jesus. Nothing is too embarrassing or shameful or awful to bring before your Father when Christ is your advocate, for his blood has won your forgiveness: "the blood of Jesus his Son cleanses us from all sin. . . . If we confess our sins, he is faithful and just to forgive us our sins and to cleanse us from all unrighteousness" (1 John 1:7, 9).

So don't try to hide your sin, minimize it, or make excuses for it.

Receive the precious gift of Christ's advocacy and the mercy of God's forgiveness.

• • • — • • •

"Sanctify them in the truth; your word is truth" (John 17:17). In this second prayer, Jesus is praying for your sanctification, or heart-transformation. We looked at this in the last chapter, but there is a connection between God's Word and his work in us: *the more we steep ourselves in the Word of Christ, the more we will absorb his heart and become like him.* So he prays for us: "I am the vine; you are the branches. Whoever abides in me and I in him, he it is that bears much fruit, for apart from me you can do nothing" (John 15:5).

Just as we want to say no to sin, we want to say yes to what is right and best. Because Jesus prays for us, we're enabled to do this. As we listen to him and obey him, we will know more of his joy and peace.

[7] Ibid., 91.

(Sounds a lot like what we teach our kids!) We will also grow to love what he loves as we raise our children, prioritizing his Word, loving our littlest neighbors, and fervently praying for them since we know he hears us and intercedes.

Jesus has his heart set on transforming ours. He's taking all that's been broken and marred by sin and, using the tool of his Word, by the handiwork of his Spirit, is remolding us and making us reflections of his beauty: "I am glorified in them" (John 17:10).

. . . ▬ . . .

"I made known to them your name, and I will continue to make it known, that the love with which you have loved me may be in them, and I in them" (John 17:26). In this third prayer, Jesus is also praying that you will know his love—not just that you will know some things *about* his love, but that you will be touched in your heart with an experience of his deepest heart for you, that you will feel what he feels for you and love him in return.

He prays that you will "know the love of Christ that surpasses knowledge, that you may be filled with all the fullness of God" (Eph. 3:19). *Yes, Lord.* If humility is "being clothed with the very beauty and blessedness of Jesus,"[8] as Andrew Murray says, then a humble mom's heart is covered and filled by Jesus's love, brimming forth to overflowing, until our children see and experience the same enduring affection he has for us, even by degrees.

"We love because he first loved us" (1 John 4:19).

Jesus's goal for you, Mom, is heaven-on-earth in the very presence of Love itself. And he will not stop interceding for you as he carries you all the way there. He *always* lives to serve you at the Father's right hand, and he will make himself known to you here and now.

How? Through his Holy Spirit.

[8] Andrew Murray, *The Essential Andrew Murray Collection: Humility, Abiding in Christ, Living a Prayerful Life* (Grand Rapids, MI: Baker Publishing Group, 2021).

BRING IT HOME

Meditate

Jesus's goal for you is that you would
be with him—that you would forever
live in the very presence of his glory—in
the heaven-on-earth that is coming.
And he will not stop interceding for you
as he carries you all the way there.

Reflect

Which of these three prayers most
encourages you right now? Why?

PRAY

Loving Jesus, my Intercessor and Advocate before the Father,

I worship you and depend upon you; I need your prayers! Thank you that your heart for me continues in heaven, that your work on my behalf never ceases. What a Savior you are! What love you have for me! Please keep praying for my protection against evil, that my heart will look like yours, and for a genuine, daily enjoyment of your deep love. Clothe me in humility to serve my kids, Lord Jesus, as you are humble and always live to serve me. Amen.

He Dwells in You

"Nevertheless, I tell you the truth: it is to your advantage that I go away, for if I do not go away, the Helper will not come to you. But if I go, I will send him to you."

JOHN 16:7

EXTRA READING: John 3:1–8; 7:37–39; 14:15–31; 15:18–27; 16:1–15

Whether we're going on a business trip or reuniting with old friends over a weekend, when we say goodbye to our children, it's like we leave a bit of ourselves behind. When I was in the hospital having our son, I was apart from our daughter for four days,[1] and my heart ached to be close to her. We sent her many messages and photos and made sure to call her often to remind her of our love.

No one knows better than Jesus what it is to be with someone "in spirit."

For he gives his Spirit not just to be with us, but to dwell *within* us.

· · · —— · · ·

What must it have been like for the disciples to have their Lord and Friend leave them?

They had already gone through the pain of saying goodbye once. Then Jesus appears, risen from the dead, speaking peace into their fears and reigniting their hearts with hope—only to ascend into heaven and disappear a second time.

Did they feel confused about what he was up to?

Were they freshly disappointed, or doubtful (again) of his promises?

Sometimes we think it would be easier to trust Jesus if we had his physical presence with us, like the disciples did when he walked the earth. *If only I could sit and talk with Jesus. If only I could understand from his own lips why he's allowing this trouble in my home. If only I could show him to my son or daughter, then they would become a Christian . . .*

The funny thing is, Jesus's own disciples struggled to believe in him when he stood beside them in the flesh. As Jesus told Thomas, sight isn't necessary for faith (John 20:29). Surprisingly, he said it would be better for the disciples if they didn't see him: "It is to your advantage that I go away."

Better for Jesus to leave? How can that possibly be?

[1] During COVID-19 when no one could visit us!

"If I do not go away, the Helper will not come to you. But if I go, I will send him to you."

Who is this Helper? And why was it better for Jesus to leave so the Helper could come?

· · · —— · · ·

"The Helper" Jesus promised to send is his very own Spirit.

The Son of God departs from his disciples in order to send his very presence *to* his disciples—or, better yet, *into* his disciples, taking up residence within them forever. "If anyone loves me, he will keep my word, and my Father will love him, and we will come to him and make our home with him" (John 14:23).

The people we make our homes with are the people we love.

And the people God makes his home with are the people he loves, and who love him.

Did you notice the Trinitarian language in the above verse? <u>We</u> *will come to him and make <u>our</u> home with him.* So, yes, it is far better that Jesus ascended into heaven because it means his presence with us is no longer limited by time and space. Truly, we (you and me and mothers today) are able to know Jesus just as well as, if not better than, his own mother who bore him, raised him, and saw him with her own eyes.

But how can this be?

Because the Spirit of Christ lives within each of his people (Rom. 8:9).

Take that in again: *Jesus wants to make his home within you.* God the Father and God the Son want to send their Spirit to live inside of you, bringing you into the bond of life and love that has existed between them from eternity past.

· · · —— · · ·

Remember how the Father, the Son, and the Holy Spirit have always existed in perfect, everlasting relational happiness?

The Trinity is the epitome of unconditional love, unrestricted delight, and fullness of joy. Just as God the Father and God the Son are two persons, so God the Spirit is also a person (not an impersonal force or power), and his particular role has always been to communicate God's love: "The Spirit stirs up the delight of the Father in the Son and the delight of the Son in the Father, inflaming their love and so binding them together."[2] He has delighted to do this since before the foundations of the world, and now, as he takes up residence in the hearts of God's people, his ministry is the same: *God's Spirit shares his life and love with us.*

When you belong to Christ, Mom, this means at least a few things:

You are never alone. The room you're sitting in right now may be empty (or maybe it's full of kids and noise), but your heart isn't—it is the home of God's Spirit. Even on lonely days when you can't remember the last time you saw a friend, you have a close companion whose comforting presence never fails. This means you can share your concerns with him in honest prayer, call on him, and depend on him. He's the only Friend who can perfectly handle and relate to every burden you carry, and who will never disappoint you.

You have a new identity. Though you were once a slave to sin, now you are an adopted daughter of God. Freed by the precious blood of the Son and reborn by the life-giving power of the Spirit (John 3:5), you no longer belong to the world but to God's eternal kingdom. You now serve him, not sin and not yourself. The Spirit will help you remember who you are in Christ when you're tempted to forget and place your identity elsewhere.

You can obey God. Because you have his Spirit, mom, you can say no to sin and yes to what is right. You can change because he's given you a new heart that loves him and *wants* to obey him! You don't need to despair, nurse bitterness, give into self-pity or shame, try to escape from your problems, resort to selfishness, grasp at control, or doubtfully wonder if God cares about your motherly situation.

[2] Michael Reeves, *Delighting in the Trinity: An Introduction to the Christian Faith* (Downers Grove, IL: InterVarsity Press, 2012), 29.

He does. There is no doubt.

He cares so much that he's made his home with you.

· · · ▬ · · ·

As Jesus was preparing his disciples for his departure, one of the most important things he shared about his Holy Spirit was this: "He will glorify me, for he will take what is mine and declare it to you" (John 16:14). The word *glorify* is common Christian language, but what does it mean? How does God's Spirit *glorify* him when he comes to dwell in us?

Here's my paraphrase:

> *The Spirit makes Jesus beautiful to us, and makes us beautiful like him.*

Or to put it another way: the Spirit causes us to *feel* what is true about Jesus's heart and the work of his hands, stirring our affections for him, so the work of our hands as mothers will increasingly flow from a humble heart of worship that looks like his.

The Spirit's ministry is beautification, magnification, *knowing*.

Consider the difference between knowing about something, and truly knowing it. Before I became a mom, I enjoyed spending time with my friends' kids, and I knew I wanted to have a baby someday. I loved the idea of it. But when I found out I was pregnant with our daughter—when an idea became a reality—I instantly loved her. The more I felt her kick and move around, the more I got to see her little form in the ultrasound, the more I anticipated her coming, my love for her deepened. When she was born, and I held her in my arms—there are no words. My affection for her has only grown the more I've come to know her.

The Spirit's ministry to our hearts is like that, and infinitely greater. He shares God's love and life with us, taking theoretical truths about him and making him our living, breathing reality. As rocking my infant daughter and feeling her warm breath was oh-so-sweeter than

her ultrasound photo, the Holy Spirit makes Jesus incomparably sweet to us, letting us taste his goodness so it's not just a nice idea, but a heart-altering reality (Ps. 34:8).

"He will glorify me, for he will take what is mine and declare it to you."

How does he declare it? Primarily through God's Word, which the Spirit brings to life within our hearts. Through it, he leads us into broken-hearted conviction when we sin against our kids or anyone else (John 16:8–9), glad-hearted rejoicing when it would be natural to complain or doubt (John 16:16–24), and inexplicable peace and comfort in chaos (John 16:25–33).

God's Spirit reveals him, beautifies him, glorifies him to our hearts through his Word.

And as Jesus becomes more beautiful to us, we will become more beautiful like him.

· · · ——— · · ·

Do you want to hear good news, weary momma? *The Spirit of the humble Christ is in us.*

In the trenches of the little years, as we wipe sticky hands and wage the naptime battle (again) and sometimes believe we deserve what no one has promised us, it's natural to be self-focused and proud; the work of our hands can be so disconnected from our hearts. But it's *supernatural* to be Christ-focused and humble, to serve our kids from the overflow of hearts filled with his Spirit. And this is his ministry. He glorifies the Son to us and through us, clothing us with "the very beauty and blessedness of Jesus."[3]

The Spirit makes us more and more beautiful like the Son.

Before he went to the cross, Jesus told his disciples,

[3] Andrew Murray, *Humility: The Journey Toward Holiness* (Bloomington, MN: Bethany House, 2001), 11.

"But when the Helper comes, whom I will send
to you from the Father, the Spirit of truth, who
proceeds from the Father, he will bear witness
about me. And you also will bear witness, because
you have been with me from the beginning." (John
15:26–27)

The Holy Spirit reveals who Jesus is and what he has done *through
his people.*[4]

The disciples would "bear witness" in a unique way, as they led
the early church, penned Scripture, and were courageously martyred
for their faith in Christ. We may not "bear witness" to Jesus in the
same context as them, but we do in our own place and time—in our
churches, in our homes, and to our children (and also before our
coworkers, neighbors, and ministry friends).

The question is, what—or Whom—do they see?

The great news is that the Spirit of truth lives within us, and he
is set on making us beautiful reflections of Jesus, our humble ser-
vant-Savior and risen Lord.

Consider some ways he does this:

Jesus made you and came to you, laying aside his heavenly glory
and lowering himself to meet your needs, body and soul. As his
Spirit convicts us of pride and touches us with his humble heart, we
are humbled, and we begin to want to serve our kids as he has first
served us.

Jesus changes you, warmly receiving every mom who comes to
him knowing she can't change herself. While only Jesus can give our
kids new hearts, the Spirit will soften us toward their spiritual plight.
He will work Christ's welcoming compassion in us, as we share the
good news that he loves to make dead and darkened hearts beat.

[4] This also tells us about the importance of the church. As a people united
in Christ and indwelt by his Spirit, we display Jesus to one another and to the
world. We are his body, the hands and feet of Christ. Moms need the support
of the local church: of peers who relate, and of older women who have gone
before us. The church is Jesus's gift to us!

Jesus satisfies you, provides for you, and leads you as you mother your children. In our weakness and longings, his strength and sufficiency are displayed through his Spirit's power who helps us trust him and actually enjoy depending on him.

Jesus loves you to the end, even to death on a cross where he took your place. While no mother can save her kids, she can point them to the only Savior. As we sin and fail, the Spirit leads us to heartfelt grief, honest confession (before God and our kids), and freeing forgiveness. He also leads us to forgive our children as God has forgiven us.

Jesus reveals himself to you through his Word by his Spirit who makes us hearers, doers, and proclaimers of the Word in our homes. With boldness and love we teach the truth to our kids, asking the Spirit to do what only he can do: open the eyes of their hearts to believe.

Jesus prays for you before the Father in heaven, and the Spirit likewise intercedes from within you, right here on earth (Rom. 8:26). To answer these prayers, God fills you with his Spirit to strengthen you to say no to sin, to bear fruit in and through you as you abide in him, and to touch your heart with a strong sense of his love. In all this work and more, the Spirit gradually makes you beautiful like Jesus, and he carries you with spiritual strength all the way to heaven.

And that is our aim, to see Jesus's glory and be like him as he is.

That is also his aim, to receive us home in his presence with a welcome that will make our weary hearts sing:

"Well done, good and faithful servant. Enter into the joy of your master" (Luke 19:17).

The Spirit makes Jesus beautiful to us, and makes us beautiful like him.

BRING IT HOME

Meditate

God the Son and God the Father want to make their home within you by indwelling you with their Spirit, who makes Jesus more beautiful to you and who makes you beautiful like him.

Reflect

How does it change your view of the Holy Spirit that his main ministry is to glorify Jesus? How might this change the way you depend on him today?

PRAY

Spirit of truth and glory,

Thank you for making your home in me! Fill my heart with the love shared between the Father and the Son. I don't just want to know some things about you; I want to know you, love you, and trust you more. May I always be sensitive to following you. Change me through your Word so I look more like Jesus; clothe me in his beauty so his humble heart is mine; and use me as a display of Christ to my kids. For Jesus's glory, amen.

CHAPTER 12

You Will See His Glory

"In my Father's house are many rooms.

If it were not so, would I have told you

that I go to prepare a place for you? And

if I go and prepare a place for you, I will

come again and will take you to myself,

that where I am you may be also."

JOHN 14:2-3

EXTRA READING: John 5:19–29; 12:20–50; 13:36–14:1–14

Having a baby is a labor of love.

First there's the waiting to get pregnant, which for many of us is a mixture of eagerness and disappointment, joy and sorrow. Then there's the nausea, the fatigue, the cravings and aversions. There's our ever-changing bodies, the aches and pains, along with the ill-fitting clothes and well-meaning reminders that, "Wow, you're getting bigger!"

The waiting continues and, every so often, we are graced with a grainy in-utero photo of our sweet baby which helps with the physical discomfort and growing fears about birth. So we put the pictures on the fridge, and we're glad we did because they make us smile and remember and press on another day.

But then the hour arrives, and labor starts. (Or, if you're like me, your babies won't budge, and you nervously go to the hospital and *pray* for labor to start.) More waiting. But this time, it's intense-pain-like-you've-never-felt-it-before waiting, as you bring a human being into the world.

It's the hardest thing you've ever done.

You wonder how you're going to make it—

But then you do. And then, a tiny wail.

Finally, a baby, a life. *You were worth it all.*

· · · — · · ·

Motherhood is not for the faint of heart. We are running a marathon, a long, strenuous race with no shortcuts, and from start to finish, *we need endurance.* Every mother does, whether you're carrying and birthing a child or waiting for months upon months for an adoptive match to finally happen. We would be lying if we said we never felt like giving up. Motherhood can feel fruitless, thankless, and unenjoyable in some seasons, and it's easy to wonder if anything we're doing is making a difference.

What will keep us going when the days feel long and the work seems endless?

Where do we find the strength to endure?

Just as we push through all the pains of childbearing or adoptive paperwork for the joy of holding our sweet little ones, someday soon the hardship and labors of this life will be swallowed up by eternity. Someday soon, Jesus will appear again, ready and eager to complete his work by carrying all his people home to a new creation. Someday soon, faith will turn to sight, and we will see with our two eyes the One whom we have believed all these years with eyes of faith.

Someday soon, our broken bodies will be whole and glorified. Someday soon, our wayward hearts will be perfect. Humble and perfect.

We will be fully and completely clothed in the beauty and blessedness of Jesus.

And so we endure, not with grin-and-bear-it "endurance" that merely gets us through another day, but with faithful, hope-filled, Christ-focused endurance that invests in the present and anticipates the future—a future promised by our Savior.

· · · —— · · ·

What will this future be like?

After Jesus washed his disciples' feet he said to them, "In my Father's house are many rooms. If it were not so, would I have told you that I go to prepare a place for you? And if I go and prepare a place for you, I will come again and will take you to myself, that where I am you may be also" (John 14:2–3).

Notice Jesus said that *he* will come again. *He* will take his people to himself.

Though exalted at his Father's right hand, Jesus won't send angels to fulfill his promise.

Nor will he take us home by any other means.

He will come for us himself.

He will leave his heavenly throne once again to fetch his people, to stay true to every word he has spoken, and to include us in his beautiful glory forever. Thomas Goodwin says it this way:

> It is as if [Jesus] had said, The truth is, I cannot live without you, I shall never be quiet till I have you where I am. . . . Heaven shall not hold me, nor my Father's company, if I have not you with me, my heart is so set upon you; and if I have any glory, you shall have part of it.[1]

Take this in: *The Lord of glory will serve his servants to the very end.*[2]

Hasn't this always been his beauty, his greatness? That such a magnificent, high, and holy God should be so good to the undeserving, so humble toward his people?

"Father, I desire that they also, whom you have given me, may be with me where I am, to see my glory that you have given me because you loved me before the foundation of the world" (John 17:24). He will serve us into eternity. Jesus's goal for his people is that we will be with him to see his glory. To enjoy and worship Jesus forever in all his beauty is our greatest good, and he will achieve this goal for us when he returns to "take [us] to himself."

We don't know when this will be (Matt. 24:36; Mark 13:32). Jesus may come back tomorrow, or in a decade, or perhaps after we've died.[3] Whenever it happens, the promise of his coming is also a promise that we will enjoy resurrected bodies in a new creation

[1] Thomas Goodwin, *The Heart of Christ* (Edinburgh, UK: The Banner of Truth Trust, 2011), 16.

[2] I take this wording from Goodwin's book on page 11.

[3] If believers die before Jesus returns, they still enjoy his immediate presence in heaven, just without resurrection bodies and a new creation; the best is yet to come. My favorite resource on heaven is my senior pastor's sermon series, *Heaven*, where he describes how the believer's death follows a *good, better, best* outcome. See Colin Smith, "Immediacy: What Will It Be Like in Heaven?" *Unlocking the Bible* (April 19, 2015), accessed May 2021, https://unlockingthebible.org/sermon/immediacy-what-will-it-be-like-in-heaven.

forever. If you belong to the Lord Jesus, Mom, this is where you are headed:

No more worry, anxiety, or fear.

No more pain from suffering, heartache from sin, or tears from grief.

No more pride or selfishness or half-hearted service.

All the darkness of this world will completely fade in the light of the Lord Jesus, and we will worship him alongside his people forever. We will be with him face to face, praise his glory, enjoy him without hindrance, reflect him without sin, and serve him without fail. Years after writing his Gospel, John was given a glimpse of this future:

> "Therefore they are before the throne of God,
>> and serve him day and night in his temple;
>> and he who sits on the throne will shelter them
>>> with his presence.
> They shall hunger no more, neither thirst anymore;
>> the sun shall not strike them,
>> nor any scorching heat.
> For the Lamb in the midst of the throne will be
>> their shepherd,
>> and he will guide them to springs of living water,
> and God will wipe away every tear from their eyes."
> (Rev. 7:15–17)

Oh, the humility of Christ never ends! Even as we serve him day and night in resurrected glory, he will not stop serving us. He will always and forever quench our thirst and satisfy our hunger as we enjoy him; he will continue to lead and comfort us as our Shepherd; and we will be secure in his embrace, never to wander, never to fear, always to be content with him and eternally grateful for what he has done.

Always to serve him with whole, humble hearts that are finally like his.

This is the place Jesus has for all those who humble themselves before him.

And it is a place of rest and honor.

<center>• • • ▬ • • •</center>

Rest and honor are two things we yearn for, but rarely enjoy in the early years of motherhood (and for some of us, we do not even get to enjoy them in the late years). We may get tastes of each—a catnap here and there, a "thank you" card on Mother's Day, some help around the house—but it's never enough. If we're looking to these things to help us endure the marathon of motherhood, we won't get very far.

Not joyfully at least.

But consider what's coming:

An eternity loving and serving the One who has first loved and served you, and who forever will.

Unending rest in his presence, and permanent residence in his house.

And more than these, perfect enjoyment of his glory, forever.

We may have few chances for rest right now, no seeming place of honor in our earthly home, and an ongoing struggle to enjoy the work of motherhood, but our heavenly future with Jesus will be the opposite of this. As Piper puts it:

> Every day for all eternity—without pause or end— the riches of the glory of God's grace in Christ will become increasingly great and beautiful in our perception of them. . . . The delight that God has in Christ will dwell in us. His joy in the Son will be our joy in the Son. And our joy will be Christ's joy in the Father.[4]

[4] John Piper, *Providence* (Wheaton, IL: Crossway, 2021), 199–200.

Everything Jesus came to accomplish will be complete, and his beauty will be reflected in his people forever. We will praise him for every way he came to serve us, an undeserving, needy people—what grace! We will finally and fully see how his glory has always been uniquely displayed in his humility, and we will worship our humble Shepherd-King, astounded that we have been included in such a magnificent purpose.

. . . ⸺ . . .

This is where all of creation is headed: the exaltation of Christ and his everlasting praise.

With that glorious, guaranteed future ahead of us, *we will endure* even when the work of motherhood is anything but glorious. *We will press on and stoop low* even when it's hard to be humble before our kids. *We will follow Jesus another day* because the promise of his second coming is equally a promise of our reward (Rev. 22:5).

In the middle of John's Gospel, Jesus says,

> "The hour has come for the Son of Man to be glorified. Truly, truly, I say to you, unless a grain of wheat falls into the earth and dies, it remains alone; but if it dies, it bears much fruit. Whoever loves his life loses it, and whoever hates his life in this world will keep it for eternal life. If anyone serves me, he must follow me; and where I am, there will my servant be also. If anyone serves me, the Father will honor him." (John 12:23–26)

Where I am, there will my servant be also.
If anyone serves me, the Father will honor him.
That is a promise.

So when you're tired of serving your kids; when you feel like giving up; when you're discouraged and weary; when everything feels out of your control; when you're sleep-deprived and can't take another

step; when your heart feels flat and cold; when you're not sure how to face another mess, another conflict, or another day of motherhood, remember:

You will see Jesus. You will be honored by the Father.

And it will have been worth it all.

We may not know what the outcome of our mothering work will be, but we know the outcome Jesus has worked for us. We know where we are headed. For the joy set before us—the joy of endlessly loving and serving him—we follow the One who has first served us (Heb. 12:1–2), who lost his life so we will keep ours for eternity.

With eyes fixed on our humble Jesus, we will endure with faithfulness.

Faithfulness means we do all things—big and small, public and private, easy and hard, glamorous and ordinary—as if serving the Lord Jesus himself (Col. 3:23–24). It means we devote ourselves to whatever work he sets before us, denying our own interests and serving our kids first because this is the way of Christ (John 12:25). It means we invest in the work he's given to us (Matt. 25) and trust he will bear fruit as he sees fit (John 12:24). And it means we aim to please him as we mother, knowing we will give an account to him when he returns (2 Cor. 5:10). Our work for Jesus is never in vain: "If anyone serves me, the Father will honor him."

With eyes fixed on our humble Jesus, we will endure through failure.

When we struggle and should we fail, Peter's story will help us savor Jesus's unending grace toward us. The disciple who courageously vowed to follow Jesus to his death (John 13:36–38) ended up denying his Lord three times. Yet, despite his terrible betrayal, Jesus forgave Peter and commissioned him to faithful love and service (John 21:15–19).

When our kids sin against us, or we sin against them; when we feel we've wasted precious time we can't get back; when we aren't sure we're doing anything right in this thing called motherhood, we will be tempted to dwell on our failures and wallow in shame. But

Jesus has compassion, forgiveness, and unending grace to help us move forward. His shed blood is the guarantee (Heb. 7:25). And sometimes, through our failures, Jesus is gracious to wake us up to reality, to expose how much we need him, and how little we can rely on ourselves and on this passing-away world. "Whoever loves his life loses it, and whoever hates his life in this world will keep it for eternal life" (John 12:25).

With eyes fixed on our humble Jesus, we will endure with hope.

Jeremiah Burroughs says, "The Lord does not so much look at the work that is done, as at the faithfulness of our hearts in doing it."[5] God sees beyond the work of our hands into the heart behind it (1 Sam. 16:7)—and our faithfulness in motherhood will waver. It's safe to say that everything we do will be tainted by some degree of pride or selfishness since our hearts have not yet been made perfect. But the good news is, Jesus is committed to changing our hearts to the praise of his glory (2 Cor. 3:18); this is why he came! For he alone has the power to transform and sustain us in the work of motherhood. So we have hope—because the risen and reigning Son of God isn't done with us yet.

Remember, Mom, *it is a humble posture of service that made (and makes) Jesus great. And so, it is a humble posture of service before Jesus that makes you great.*

And his humble heart is *for you.*

He is working in you what is pleasing to him.

He is changing you into his likeness.

He is making you a humble mom who serves him with your hands—

And also with your whole heart.

[5] Jeremiah Burroughs, *The Rare Jewel of Christian Contentment* (Edinburgh, UK: The Banner of Truth Trust, 1964), 199.

BRING IT HOME

Meditate

Jesus's goal is for you to be with him forever, taking in his glory, endlessly loving and serving him with a perfect, humble heart and imperishable body that is finally and fully clothed in his beauty and blessedness.

Reflect

What have you learned about Jesus, his heart and hands, throughout this book? What have you come to treasure most about him?

PRAY

Beautiful Lord Jesus,

What can I say in response to who you are? Your humility is truly glorious. That you would give yourself for an unworthy people so we would share in your joy and serve you forever— this good news stops any pride and stirs the heart to worship. Thank you for making me, coming to me, changing me, satisfying me, providing for me, leading me, loving me, taking my place, revealing yourself to me, praying for me, dwelling in me, and bringing me to glory. I love you, Lord Jesus, and I need you. Change my heart and help me faithfully serve you with gladness as I serve my children, even when it means stooping low. Make me a humble mom, Lord Jesus. I look to you, for you are my life. Amen.

Acknowledgments

It is Mother's Day 2021. It is a very good day, not only because I love being a mom, but because this book is finally done. God has been very gracious to see it to completion in a demanding season, and his grace has come in many forms.

Thank you to Ashley Gorman and her team at B&H for pursuing me as a writer and believing in this project. I love that you're a mom, Ashley, and that your heart was in this message from the start! May the Lord deepen your love for him as you serve your family and your authors.

Don Gates, you are so good at what you do, and I am grateful to be represented by you.

My dear friends and fellow moms Julie Gernand and Caitlin Plascencia read every word of this manuscript and gave invaluable feedback. Thank you for serving me on top of everything else you do. *Humble Moms* is better because of you, dear ones.

My sweet kids were so well cared for while I worked on this book. Thank you, Leah Paraskevas, for being a faithful babysitter, someone they trust and look forward to seeing each week.

Both my mom, Jennie Evensen, and my mother-in-law, Beth Wetherell, read everything I wrote, and I value your encouragement and feedback because *you've lived it*. Thanks for taking the time, and for your love and constant support.

To my momma: You are a humble mom. I have watched you grow in grace, love the Lord Jesus, feed on his Word, pour out your heart

to him in prayer for your kids, and faithfully serve him (and us) in motherhood. What I know and enjoy about being a mom, I learned from you. So thank you for loving us so well and pointing us to Christ. (And I am so *sorry* for all the tears, sleepless nights, and panic I caused you! I get it now. You're a trooper!)

I never cease to be amazed at God's grace in leading us to The Orchard, our wonderful church. Thanks to Colin Smith, Scott Lothery, our church board, and our campus pastors (my husband included) for keeping us committed to Jesus and his Word.

To my husband, Brad: When I didn't think I could write this, you believed I could. When I felt discouraged along the way, you prayed for me and encouraged me to press on in God's strength. Thank you for being a faithful husband and father, and a humble one at that. You serve us so well. I love you!

John and Joanna, not a day goes by that I don't look at you in amazement. You are both unexpected gifts from God, and being your mom is my favorite job, hands down! I hope you get to read this book someday and see what a means of God's grace you are to me. I pray you know the great privilege of one day becoming parents, but mostly, the greater privilege of being part of God's family through Christ. I love you both.

Precious Lord Jesus, where else can I go? You are my life, and I love you. The ways you have served me are beyond comparison. You have satisfied my longing soul. You have kept me going when I couldn't take another step. Thank you for never giving up on me, for loving me to the end, even to the end of an offering so small as this book. You did this, Lord, because I have no idea how it got done. It is yours. *From you and through you and to you are all things. To you be glory now and forever. Amen.*

Discussion Questions

Introduction: What's in a Mom?

1. The introduction of this book opened with many different descriptions of how moms might be feeling right now. Which description resonates with you most right now? What would you add to that list? You might consider:

- What it is about motherhood that makes you most weary these days?

- What is bringing you the most joy these days?

2. As it relates to mothering in this season, what is the current state of your heart?

- What are your current struggles (e.g., fear, distraction, overwhelm, pride, self-pity, indulgence, apathy)?

- Are you in a season of enjoying the Lord? Or do you feel far from him?

3. Where do you find the most obvious disconnection between your hands and heart as you serve your kids? Give some examples.

4. Reread Philippians 2:1–11 out loud as a group.

- What does it tell you about God?

- What does it tell you about yourself?

- How has Jesus Christ humbled himself, according to this passage?

5. How is it good news that Jesus lives to serve his people—including mothers?

6. What do you hope to take away from this book?

Chapter 1: He Made You

1. Read John 1:1–4 and Genesis 1:1–3 out loud as a group.

- What similarities do you notice between the two passages?

- Why does John call Jesus "the Word"?

2. Describe the Trinity in your own words. How are the three persons of the Trinity the same and also distinct?

3. What difference does it make that "all things hang upon, rely upon, depend upon the Word of life"?

- What aspect(s) of motherhood have you been trying to sustain yourself?

- Why is it good news that Jesus sustains the whole universe?

4. What is the difference between (1) possessing created worth and (2) being worthy of our Creator? Why is it important to distinguish between the two?

5. Where or how do you struggle to believe that you (and your kids) aren't a burden? What would it look like this week to trust God's constant mindfulness of you?

⚛ Chapter 2: He Came to You

1. When is it hardest to serve your kids? Easiest?

2. How would you describe Jesus's incarnation in your own words?

3. Read Romans 1:21–25 out loud as a group.

 - What does it tell you about God?

 - What does it tell you about yourself?

 - How does grasping the depths of human sin help us better grasp the humble lowliness of Jesus?

4. What glories did Jesus leave behind him when he came to earth?

 - What are some glories you've had to give up as a mom?

 - How does it strengthen you to know Jesus has gone before you in this?

5. What would it look like this week to savor Christ's incarnational love as you stoop low to serve your kids?

⚛ Chapter 3: He Changes You

1. What are some of the world's views about how a person can change?

 - In what ways do you find yourself believing and pursuing these?

 - How do they fall short?

2. In what ways, if any, do you relate to Nicodemus?

3. Read John 3:16–21 out loud as a group.

 - What does John tell us about sin in this passage?

 - What has God done in response to our sin?

 - How does God invite us to respond?

4. How is it good news that Jesus warmly receives all those who humbly come to him? What does coming to him look like for you right now?

5. If our hearts are dead in sin, how can they be made alive?

6. Moms can't produce lasting heart-change (in ourselves or our kids), but Jesus can.

- What difference might this make for you today?

- How might you enjoy Jesus in a new way this week?

ᨐ Chapter 4: He Satisfies You

1. As a mom, what are you usually thirsty for?

- What do you turn to for satisfaction?

- Do these things satisfy you?

- How can you usually tell when these things have failed to satisfy you?

2. In what ways, if any, do you relate to the infamous Samaritan woman? Do you relate more to her, or to Nicodemus?

3. The only thing that qualifies us for Jesus is our lack of qualifications, our humble position of need before him.

- How does this reality free you to come out of hiding and come to Jesus?

- How might this change the way you interact with your kids, especially when they mess up?

4. Read John 4:7–15 and John 7:37–39 out loud as a group.

- What does it mean that Jesus offers us living water?

- How do you think his offer made the Samaritan woman feel? How does it make you feel?

5. Do you view Jesus warily, like the Samaritan woman? Or do you believe he wants to satisfy your longing soul? What would it look like to believe him this week?

Chapter 5: He Provides for You

1. In what areas of life are you most prone to disbelieve that God will provide for you? (Think about when you most struggle with worry, doubt, or fear.)

2. Read Hebrews 2:14–18 out loud as a group.

- Why did Jesus have to be made like us in every respect?

- How does it make you feel to know that in your depleted moments, Jesus knows what you're feeling?

3 What weaknesses do you most dislike or push against? What difference does it make that God tailor-makes our limitations for his purposes?

4. How might God actually be answering your prayers by *not* giving you what you want or think you need? How is this his grace to you? Think of an example of a time when this was true.

5. Compassion is what most readily pours out from Jesus's heart toward the humble.

- Do you believe this? Or do you tend to believe something else will pour out of Jesus when you approach him in failure or weakness?

- How would your approach to Jesus change this week if you took to heart his yearning to help you in your weaknesses?

Chapter 6: He Leads You

1. At the halfway point in this book and in John's Gospel, is Jesus who you expect him to be? What has surprised you most about him?

2. Read Ezekiel 34:1–6 and 11–16 out loud as a group.

- In what ways did Israel's kings fail?

- Do you see any of their motivations within yourself?

- What did God promise his people?

3. Name some ways that Jesus is the ultimate fulfillment of a great leader. What makes him the Good Shepherd? How does this compare with our culture's definition of leadership?

4. Identify one area where you are needing wisdom to lead your kids. Which of the four marks of Jesus's loving authority do you need most right now, and why?

5. What would it look like this week to entrust yourself to Jesus's gentle leading? How might this change the way you deal with your kids?

Chapter 7: He Loves You

1. Do you ever question Jesus's love? Why do you think that is?

2. How does our surrounding culture define love? Does this square with who God is? Why or why not?

3. In which of your circumstances do you most need to know that nothing at all exists outside of Jesus's loving authority?

4. Read 1 John 4:7–12 out loud as a group.

- How do we know God loves us?

- What reasons does John give for us loving one another?

5. What are some of the most demanding parts of motherhood that make it hard to love your kids? How does Jesus's promise to love you "to the end" empower you to love?

6. How would an attitude of humble worship change the way you serve your kids this week?

🌿 Chapter 8: He Takes Your Place

1. If you're comfortable, tell us about a time when you sinned against your kids. Describe what happened and the aftermath (e.g., hiding, shame, confession, etc.).

2. Why is Jesus's sacrifice a matchless one, something we're not able to fully imitate? In what ways do we try to as moms?

3. Read Romans 5:6–11 out loud as a group.

- How does God show his love for us?
- What does it mean to be "justified by [Jesus's] blood"?
- What does it mean to be "reconciled to God" by Jesus's death?

4. Since our sin will always be our biggest problem, how does this put other problems in proper perspective? Give an example.

5. How does Jesus's finished work on the cross apply to the next time you sin?

6. How does Jesus's finished work on the cross apply to your kids' salvation from sin? And how does this free you from the unattainable pursuit of saving them yourself?

🌿 Chapter 9: He Reveals Himself to You

1. How is Jesus's resurrection a past, present, and future reality?

2. Put yourself in Mary's shoes. When you think about Jesus walking out of his tomb, how does this make you feel? How does it affect your discouragements?

3. Read John 20:30–31 out loud as a group.

- Jesus revealed himself to Mary and Thomas by speaking to them. According to John, how does he reveal himself to us?

- What invitation(s) does Jesus give us through our Bibles?

4. How would you describe your current appetite for God's Word? Are you hungry for it, apathetic about it, or averse to it?

5. Jesus has spoken to us so our joy will be full. What would it look like to run to the living Word of the living Christ *for your joy* this week?

Chapter 10: He Prays for You

1. Is the reality of Jesus's heavenly ministry new to you?

- What surprises you about it?

- What questions, if any, do you have about it?

2. Jesus is both our *intercessor* and *advocate* in heaven. How would you describe these two roles in your own words?

3. Read John 17 out loud as a group. (It's a longer one, so maybe trade off reading a few verses each. It'll be worth it!)

- What is Jesus's goal for his people?

- What are a few of Jesus's prayers for you?

4. What does it mean that in Christ you have the ability to say no to sin and yes to righteousness? What does it look like to "be who you are in him"?

5. Can you share about a time when the Spirit touched you with a felt sense of God's love?

6. How might it strengthen you this week to know that Jesus is praying for you all the time?

Chapter 11: He Dwells in You

1. Read John 16:4b–15 out loud as a group.

- Why was it better for Jesus to leave so the Holy Spirit could come?

- What are some aspects of the Spirit's ministry?

2. When you belong to Christ and his Spirit lives in you, this means (1) you are never alone, (2) you have a new identity, and (3) you can obey God. Which of these three truths encourages you most right now, and why?

3. The Spirit makes Jesus more beautiful to us, and makes us more beautiful like him.

- Have you thought of the Spirit's ministry this way before now? How does this make you feel?

- Has the Spirit glorified the Son to you lately? How has he caused you to treasure Jesus more?

4. How can you tell when you're walking by the Spirit as you mother your kids? Quenching the Spirit? Give some examples.

5. What is one way the Spirit has made you more beautiful like Jesus over the years? What is one way you'd like to look more beautiful like Jesus this week?

Chapter 12: You Will See His Glory

1. What is making your days feel long right now? In what ways are you needing endurance?

2. Read John 14:1–7 out loud as a group.

- What does this passage tell you about heaven?

- How is a person able to enjoy heaven? How do we arrive there?

- How does this encourage you to pursue Jesus with all your heart right now?

3. Read Revelation 7:15–17 out loud as a group. How will Jesus continue to serve us forever in heaven?

4. How does your heavenly future of seeing Jesus and being honored by the Father help you press on in motherhood right now, when it feels like there is little rest and honor?

5. What does it mean to be faithful in motherhood?

6. What have you learned about Jesus, his heart and hands to serve you, throughout this book? What have you come to treasure most about him?